Mammals

Michel Lauricella

MORPHO

anatomy for artists

rockynook

Morpho: Mammals
Michel Lauricella

Editor: Maggie Yates
Project manager: Lisa Brazieal
Marketing coordinator: Katie Walker
Graphic design and layout: monsieurgerard.com
Layout production: Hespenheide Design

ISBN: 978-1-68198-997-6
1st Edition (1st printing, April 2023)

Original French title: Morpho Mammifères
© 2022, Éditions Eyrolles, Paris, France
Translation Copyright © 2023 Rocky Nook, Inc.
All illustrations are by the author

Rocky Nook, Inc.
1010 B Street, Suite 350
San Rafael, CA 94901
USA
www.rockynook.com

Distributed in the UK and Europe by Publishers Group UK
Distributed in the U.S. and all other territories by Ingram Publisher Services

Library of Congress Control Number: 2022945514

This book is printed on acid-free paper.
Printed in China

Publisher's note: This book features an "exposed" binding style. This is
intentional, as it is designed to help the book lay flat as you draw.

How Is This Book Arranged?
I have chosen to divide this book into three main sections, corresponding to three environments: the earth, the air, and the water. The terrestrial mammals are obviously the most numerous of these: the three sections are therefore not all the same size, and we have further divided the terrestrial environment into sub-environments, from underground to the tree canopy.

I will not deal with the urban environment here, because the many species of rodents, bats, and monkeys that live there are not different from their wild forms.

table of contents

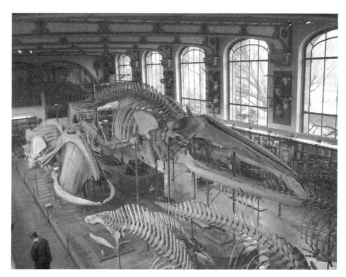

*The Gallery of Paleontology and Comparative Anatomy
of the National Museum of Natural History, in Paris.*

foreword

In the 18th century, Carl Linnaeus classified living forms based on their similarities. A century later, Charles Darwin imagined kinship links between the species, which have now been confirmed by genetics. We mammals are therefore related, and it shows: you can see the outlines of that relatedness. Our bodies have a shared design that can be perfectly identified—this is one of the keys to the theory of evolution. In order to make it clear, I will rely, when necessary, on the skeleton. Thanks to comparative anatomy, we will learn to recognize the homologous segments (the segments that have the same origins): to find, for instance, our own hand in the drawing of the foreleg of a zebra or a mole, in the wing of a bat, or in the fin of a dolphin. Our aim here is to define the characteristics that are shared among this class of animals to which we belong, to establish links between forms and functions, but also to understand the evolutionary processes that have caused these shapes to become different depending on their ecosystems. These ideas and observations should help you to create shapes that are both imaginary and realistic.

introduction

In a small book like this, all we can really present is a beginning: I am not a scientist, but for the sake of drawing, and especially for drawing from imagination, it can be useful to keep in mind the ways in which natural selection works to tinker with shapes. Darwin and the geneticists who followed him have described the fine balance between chance and adaptation. Numerous mutations, which are favored by sexual reproduction and are entirely part of the process, generate variation, which is the basis for natural selection. The environment, in the broadest sense of the word—in other words including geography, climate, food resources, predation, and peers—is what does the selecting. It is the main constraint that influences living beings. The many similarities that result from evolutionary convergence—when species with completely different ancestries end up looking strangely alike when they live in similar environments—are a spectacular testimony to this fact.

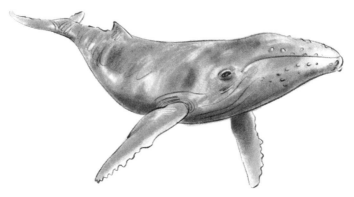

*The humpback whale (*Megaptera novaeangliae*).*

To wander through a natural science museum, such as the Paleontology and Comparative Anatomy wing of the National Museum of Natural History in Paris, is to experience the evidence of this: we belong to the same world, to the same community of living beings. These skeletons look alike, and it is not a coincidence that they come together in these places. All of these vertebrates have a skull and a vertebral column; most of them also have a ribcage and limbs arranged in pairs. One quickly begins to feel that their differences are an indication of particular aptitudes: one animal is built for running, another one for swimming—or climbing, or flying...

By the simple fact of their existence in the world, all of the current forms bear witness to their adaptations. In a universe that is in constant motion, these forms are the way they are at "time T" and will have to give way to other forms every time that the environment, or the power relations within the environment, change. As a result, the many, countless forms that have disappeared—another key to the theory of evolution—are richly instructive for us.

How to choose, faced with this kind of multitude? I have selected about a hundred living species, choosing from among the most spectacular, the most "readable," and those that best illustrate my point. The vision presented here is therefore somewhat distorted, because there are many forms whose adaptations are less visible than in the forms I present here.

Nor will I discuss domestic animals, all of which are a product of artificial selection, namely by their breeders—and this, too, is another important key to the theory of evolution as laid out by Darwin (see *The Origin of Species*)— I prefer to limit myself to the forms of wild animals.

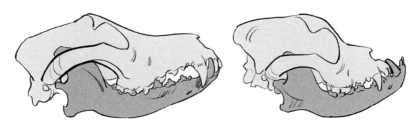

The different breeds of dog have been derived from the wolf by artificial selection. The skull of the German shepherd at left is close to that of its wild ancestor (see p. 37, fig. 5). The same is not true for the boxer, at right, which is a testimony to the extreme choices made by breeders.

What Distinguishes Mammals?

Mammals are vertebrates, like all animals with backbones, which also includes fish, amphibians, reptiles, and birds.

Mammals have lungs, like most adult amphibians and like reptiles and birds.

Most mammals are viviparous (meaning they produce live births: the egg develops completely inside the uterus, so that at birth the young appear already formed), but so are many fish and reptiles; meanwhile, platypuses and echidnas, although they are also mammals, lay eggs.

As a result, zoologists make a distinction, among the mammals, between monotremes, who lay eggs; marsupials, whose young are born in an embryonic state and have to continue their development in their mother's ventral pocket; and placentals, whose young are fed through the placenta, in connection with the mother's circulatory system.

Mammals are called "warm-blooded" (homeothermal), but so are birds. And here too we need to observe nuances, because some mammals (such as echidnas and camels) experience significant variations in their internal temperature depending on the ambient temperature, and others do so during periods of hibernation.

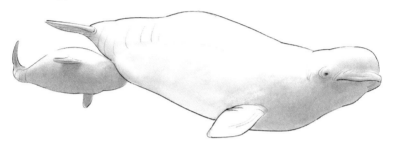

*Female beluga (*Delphinapterus leucas*) nursing her calf.*

Etymologically, the word "mammal" comes from the Latin *mamma*. The monotremes (platypuses and echidnas), however, do not have udders. But what all mammals do share is that they have mammary glands. The platypus's milk leaves its body through a large number of skin pores and then oozes through its fur, where the baby catches it.

Hair, or fur, in fact, is itself also a mammalian characteristic, with its particular structure and its role as an insulating cover, made impermeable through the action of many glands. This is an important role for warm-blooded animals (for birds, their feathers play the same role). On elephants, rhinoceroses, and hippopotamuses, the hair is very sparse. On some whales, it makes only a brief appearance during the embryonic development: for these whales, a thick layer of fat takes care of insulation.

On furry creatures, their fur is usually oriented from the end of the muzzle towards the tail: this is the direction in which we pet or brush a cat. This is also what allows mice to slip easily into the tiniest cracks or holes in walls, deer to make their way through the undergrowth, and otters to glide through the water. Mole fur, on the other hand, is flexibly implanted. It can just as easily lie in one direction or the other, which is an advantage when moles are moving around in their underground galleries: they can go backwards without getting dirt under their fur.

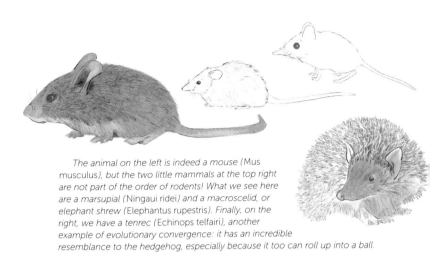

The animal on the left is indeed a mouse (Mus musculus), but the two little mammals at the top right are not part of the order of rodents! What we see here are a marsupial (Ningaui ridei) and a macroscelid, or elephant shrew (Elephantus rupestris). Finally, on the right, we have a tenrec (Echinops telfairi), another example of evolutionary convergence: it has an incredible resemblance to the hedgehog, especially because it too can roll up into a ball.

Fur and hair can also become defensive: the quills of the hedgehog are made up of keratin, just like our hair and nails. The same is true for "mustaches," or vibrissae, the bristles that generally grow around the muzzle, under the eyes, and on the paws, and are sensitive to the slightest vibrations.

In certain regions with very well-defined climates, fur and hair can vary in length and color depending on the season. The animal molts to produce winter fur or summer fur. The fur can be either uniform in color or made up of bands of various hues, offering the animal a "camouflage outfit:" spots and stripes can blur the look of the animal's silhouette and allow predators (such as leopards and tigers) to avoid being seen, or allow prey to hide. Thus, in many species, we often find stripes (such as in the wild boar) or spots (as in the fawn) on the young and the females, which are in a precarious situation during gestation, at birth, and while caring for their offspring. Some males, meanwhile, sport veritable ornaments, such as the gelada, the great ape that has strong coloration on some bare areas of its body during mating season, or the lion, whose mane is a strong signal that also plays the role of a shield against bites by its rivals.

The gelada (Theropithecus gelada).

Verreaux's sifaka
(Propithecus verreauxi).

We should note that the hairs often form very well-defined regions on the body. When they are cold, mammals control their body temperature by curling up into a ball, to reduce their uncovered surface: what is visible then is their guard hairs, which insulate them. The hidden parts can have shorter hair or fur or be bare: this is the case for the underbelly and the inside of the legs. These zones, meanwhile, can be uncovered or soaked in water if the animal is too hot. They can constitute more sensitive, even erogenous, zones.

Sexual dimorphism, when it is present, is the source of forms that are sometimes implausible and seem to contradict the theory of natural selection. For instance, how can we consider the deer's antlers, the babirusa's teeth (see p. 44), or the narwhal's tusk (see p. 93) as an advantage? There are many such examples, which requires us to think in terms of a sexual selection that is added, in a certain sense, to environmental selection. When the conditions for survival are taken together, we can find morphological or behavioral characteristics within a species that would seem to be very real handicaps for individuals. It is usually the males, who of course do not have to deal with the constraints of gestation, birth, and breastfeeding, that are most often affected by this excessiveness. They may display risky, aggressive, or territorial behavior; their size, their horns, their antlers, or their teeth may exceed what the animal needs, strictly speaking, and can even provide a disadvantage. But a male that reaches the age of reproduction will be recognized by its peers as carrying a strong genetic heritage—and recognized, in particular, by the females, who will select it for these secondary sexual characteristics. And as a result, these characteristics will be passed on within the species and sometimes take on surprising proportions.

In the context of this small volume, I will leave it at that. Do note, however, that almost all mammals have seven cervical vertebrae; this is true whether we are talking about giraffes, whales, or human beings. The exceptions can be counted on one hand: three species of sloth (which have between six and nine cervical vertebrae) and the manatee (6 cervical vertebrae) are the only ones to deviate from this law.

Right profile of the fused first four cervical vertebrae in the orca (Orcinus orca).

The Skeleton

Our goal here is to be able to identify the various adaptive characteristics, beginning from a hypothetical shared design. For this purpose, I will take the risk here of drawing an imaginary mammal, a chimera with the largest possible number of shared features, whose body is an amalgam of the most common characteristics. I have schematized these features and reduced them to simple shapes. These sketches may make it easier for you to conceive of the adaptations that we will see in greater detail in the following pages.

At the front of the body, the head combines the nerve center (the brain), the main sense organs (sight, smell, and sound), and the opening of the digestive system (the mouth). The design of the head can be thought of as beginning with the skull, or cranial box, a true "exoskeleton" whose function is to protect the brain and to connect it with the spinal cord, which slips into the flexible and resistant spinal system.

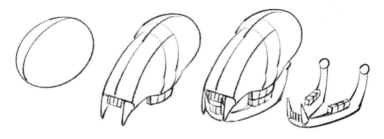

This animal will have to eat, so next I draw its jaw. The upper jaw is fused to the skull (this is not always the case for other vertebrates), and only the lower jaw, or mandible, is mobile. Mammals have specialized teeth. There is very often a distinction between the incisors, which are sharp; the canines, which tear, and the robust grinding molars, in the back.

The orbital and nasal cavities have their own position in the architecture of the face. They are positioned between the main columns of bone.

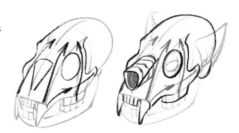

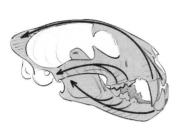

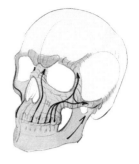

Panther (Panthera pardus) and human (Homo sapiens) skulls.

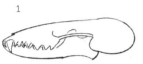

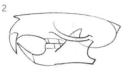

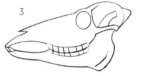

A few typical examples of skulls: insectivore (mole, 1); rodent (rat, 2); herbivore (doe, 3); carnivore (puma, 4); omnivore (boar, 5, and human, 6).

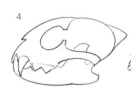

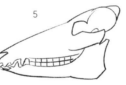

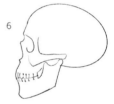

Thus, mammal skulls offer a large variety of forms. In addition to the constraints based on diet, there are offensive and defensive characteristics. Because the mouth can always be a potential weapon, some teeth are specialized, such as the walrus's or warthog's canines or the elephant's incisors. The list is long!

Horns and antlers also come in different varieties: bison horns, rhinoceros horns, deer antlers, etc. The weight of these growths and the kind and frequency of the blows that are sustained inevitably redesign the architecture of the skull. The orbital and nasal cavities and the auditory cavities are thus positioned between the bony columns that are required by the con- straints of the jaw and, when relevant, the constraints of the horns.

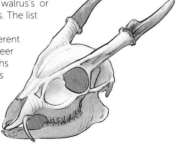

Reeves's muntjac (Muntiacus reevesi), a deer with long canines.

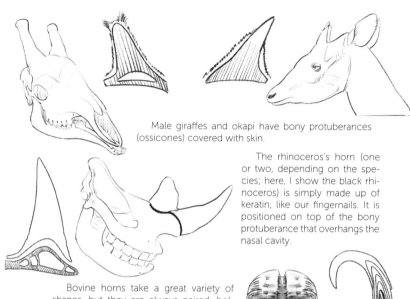

Male giraffes and okapi have bony protuberances (ossicones) covered with skin.

The rhinoceros's horn (one or two, depending on the species; here, I show the black rhinoceros) is simply made up of keratin, like our fingernails. It is positioned on top of the bony protuberance that overhangs the nasal cavity.

Bovine horns take a great variety of shapes, but they are always paired, hollow, and permanent. (Here I show a musk ox, but this is also true for gazelles, wildebeest, sheep, goats, etc.) They consist of a bony peg (or horn bud), covered by a horny sheath. Bovine species can have horns in both sexes or just for the males.

Cervids (such as deer, roe deer, reindeer, elk, and fallow deer) have antlers, bony organs that fall off and grow back every year on the heads of the males (and, for reindeer, also on the females). At first, the antlers are covered in a richly vascularized, velvet skin. During the mating season, they remain bare.

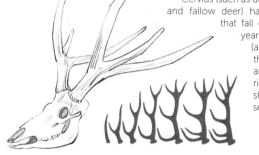

Annual growth phases for antlers (based on the Nordisk familjebok *encyclopedia).*

Let's now return to the drawing of our typical mammal. After the head, I draw the spinal column, in five parts (Fig. 1: cervical, thoracic, and lumbar vertebrae, followed by the sacrum and coccyx). Then I draw the ribcage, which protects the heart and the lungs, accommodates the attachment of the trunk and forelimb muscles, and allows a volume of air to enter during breathing.

All that is left is to attach the limbs, using the shoulder girdle (scapula/clavicle/sternum) and the pelvic girdle (the pelvis). The shoulder girdle is mobile. The scapulae or shoulder blades (the first bony elements that make up the shoulder girdle) are connected to the ribcage by muscles and tendons. They are then articulated to the clavicles, and the clavicles in turn to the sternum (the ventral part of the ribcage). The pelvic girdle, which connects the rear limb to the spinal column, is entirely bony and made up of the pelvis, articulated to the sacrum.

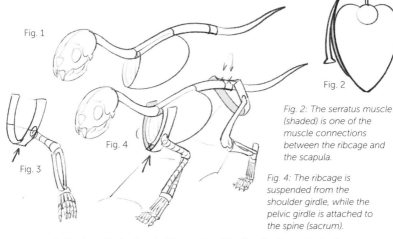

Fig. 1

Fig. 2

Fig. 3

Fig. 4

Fig. 2: The serratus muscle (shaded) is one of the muscle connections between the ribcage and the scapula.

Fig. 4: The ribcage is suspended from the shoulder girdle, while the pelvic girdle is attached to the spine (sacrum).

In the hypothetically primitive posture (Fig. 3, gait of an actual salamander), the limb is thrown off to the side and is used both for lifting off the ground (elbow and knee) and for stepping forward (shoulder and hip).

From this posture, we move to a more dynamic posture, bringing the joints closer to the center of gravity (Fig. 4, knee and elbow still bent). This allows the animal to better control its weight (in a leap and in the landing that follows it), and all of the joints are extended in the direction of movement (lifting and moving forward at the same time).

In the back, the limb, bent to the side, and the knee, to the front, keep the same construction. The tibia and fibula remain parallel, whereas in the front the fact of pulling the elbow backwards while keeping the extremities of the legs facing forward requires the bones of the foreleg to be twisted. The radius and the ulna intersect!

This is a heavily schematic and imaginary vision of an "average mammal," based on which we will analyze the differences in shape, proportion, and function. The rear thrusting mode is exaggerated in a kangaroo, whereas in a mole it is the forelimbs that do all the work of digging, and in a bat it is also the forelimbs that do all the work of flying.

The extremities can be simplified by only keeping one toe (as in a zebra) or even being reduced to the point of invisibility under the skin (as in a dolphin).

All of the limbs are theoretically built along the same pattern. There is only one bone in the first segment (the humerus in the front and the femur in the back), two in the second (radius/ulna in the front and tibia/fibula in the back), a series of small bones (at the wrist and the heel), and then five digits, each made up of a meta and several phalanges.

Fig. 1 and 2: In terms of the bones, the shoulder girdle is often reduced to just the scapula. .

Fig. 3: Scapula of the giant anteater (Myrmecophaga tridactyla).

Fig. 4 and 5: The pelvic girdle includes the pelvis, made up of bones that come together around the hip joint (iliac, ischium, and pubis) and are then connected to the spinal column by the sacrum, which is itself made up of a variable number of vertebrae that are fused together. In the dolphin, the pelvis is reduced to two long bones buried in the flesh.

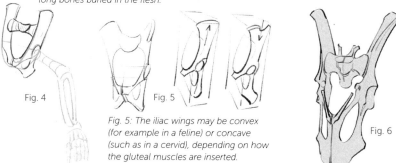

Fig. 5: The iliac wings may be convex (for example in a feline) or concave (such as in a cervid), depending on how the gluteal muscles are inserted.

Fig. 6: The pelvis of the kangaroo (Macropus giganteus). In marsupials, the forward part of the pelvis has two long extensions attached to the pubis (marsupial bone) which run obliquely forward and support the pouch in which the young spend the first part of their lives, suspended from their mother's breasts. These bones also exist in the males, who do not, however, have a marsupial pouch.

In this small book, I will emphasize the skeleton. This will give you the foundations that you need in order to define the axis and proportions of each animal's main segments.

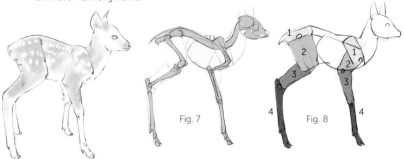

Fig. 7

Fig. 8

Fig. 7 and 8: The demonstration provided here, using a fawn, will be valuable, and reused, throughout this book. Each limb is made up of four segments. I have chosen to use terms taken from human anatomy. Thus, the forelimb includes the shoulder (1, scapula), the arm (2, humerus), the forearm (3, radius and ulna), and the hand (4). The hind limb includes the pelvis (1), the thigh (2, femur), the leg (3, tibia), and the foot (4).

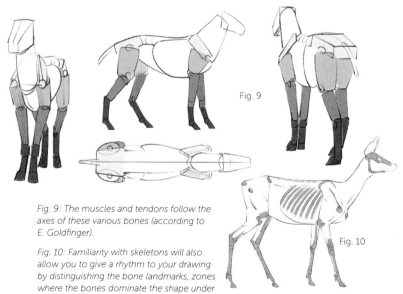

Fig. 9

Fig. 9: The muscles and tendons follow the axes of these various bones (according to E. Goldfinger).

Fig. 10: Familiarity with skeletons will also allow you to give a rhythm to your drawing by distinguishing the bone landmarks, zones where the bones dominate the shape under the skin (shaded areas).

Fig. 10

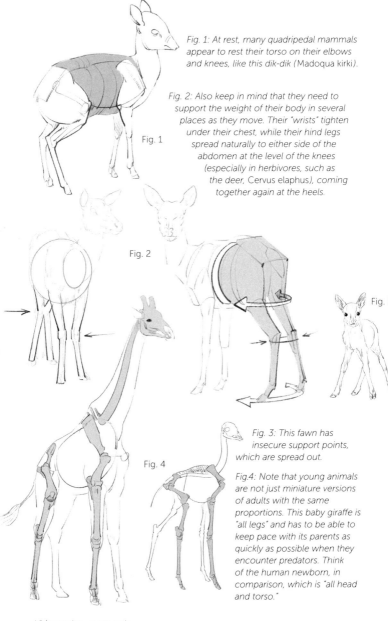

Fig. 1: At rest, many quadripedal mammals appear to rest their torso on their elbows and knees, like this dik-dik (Madoqua kirki).

Fig. 2: Also keep in mind that they need to support the weight of their body in several places as they move. Their "wrists" tighten under their chest, while their hind legs spread naturally to either side of the abdomen at the level of the knees (especially in herbivores, such as the deer, Cervus elaphus), coming together again at the heels.

Fig. 1

Fig. 2

Fig. 3

Fig. 3: This fawn has insecure support points, which are spread out.

Fig. 4

Fig.4: Note that young animals are not just miniature versions of adults with the same proportions. This baby giraffe is "all legs" and has to be able to keep pace with its parents as quickly as possible when they encounter predators. Think of the human newborn, in comparison, which is "all head and torso."

plates

There are many burrowing species, because the underground environment provides a more stable temperature, shelter that is less exposed, and food reserves that can be significant (earthworms, insect larvae, roots, etc.). The species who are the best adapted to this kind of environment share a number of features in common: their small size; atrophied eyes and ear flaps; powerful forelimbs (for traction mode) equipped with a powerful shoulder musculature that fills up the neck region; and short, silky fur that is flexibly implanted. Note that it is not the lack of usage of their eyes that causes the atrophying; the theory of evolution requires a different interpretation.

The European mole (*Talpa europaea*, Fig. 1) has tiny eyes that are bad at seeing shapes, but reasonably good at seeing movement. Its ears have no flaps. Its pointed snout is a tactile organ.

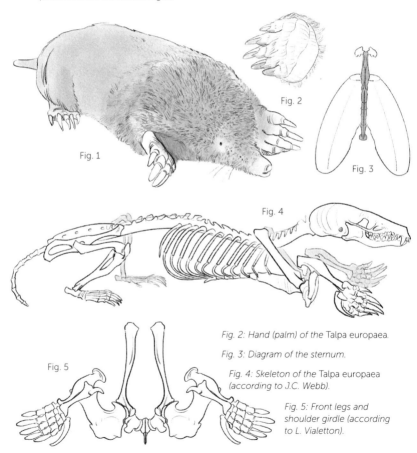

Fig. 2: Hand (palm) of the Talpa europaea.

Fig. 3: Diagram of the sternum.

Fig. 4: Skeleton of the Talpa europaea (according to J.C. Webb).

Fig. 5: Front legs and shoulder girdle (according to L. Vialetton).

Golden moles (here the Cape golden mole, *Chrysochloris asiatica*, Fig. 6) look very much like European moles (see opposite page); but they do not belong to the same order: here, again, this is a matter of convergent evolution.

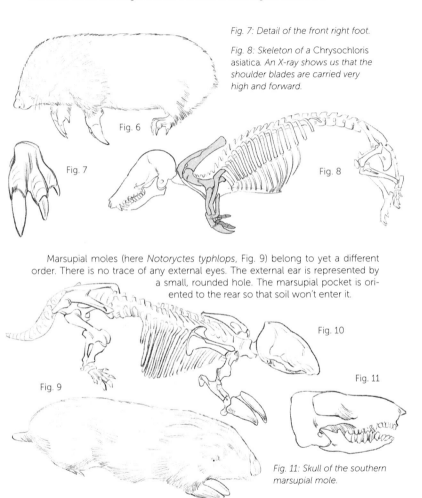

Fig. 7: Detail of the front right foot.

Fig. 8: Skeleton of a Chrysochloris asiatica. *An X-ray shows us that the shoulder blades are carried very high and forward.*

Fig. 6

Fig. 7

Fig. 8

Marsupial moles (here *Notoryctes typhlops*, Fig. 9) belong to yet a different order. There is no trace of any external eyes. The external ear is represented by a small, rounded hole. The marsupial pocket is oriented to the rear so that soil won't enter it.

Fig. 10

Fig. 11

Fig. 9

Fig. 11: Skull of the southern marsupial mole.

Fig. 10: Skeleton of the southern marsupial mole. The two large arched and compressed nails of the third and fourth front toes hide the thin, atrophied nails of the thumb and index finger.

But natural selection does its "tinkering" based on the anatomical elements available within each order of animals. The rat mole (*Spalax leucodon*, Fig. 1) is a rodent equipped with the strong incisors that are characteristic of its order, and it is with these teeth that this animal digs its galleries, while using its paws to brush away the soil. Its eyes are completely covered by its skin.

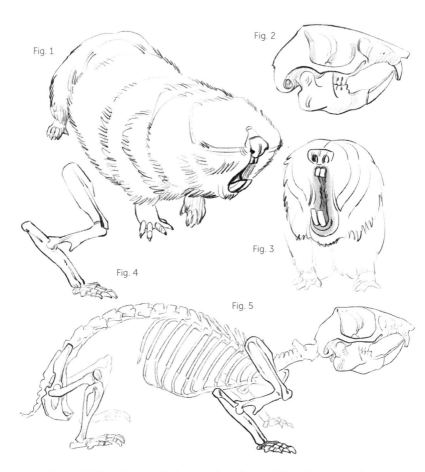

Fig. 2 and 3: There is cheek skin between the incisors and the molars that can be tightened in order to keep soil from penetrating.

Fig. 4 and 5: The front limbs are still strong: note the lever arm formed by the ulna (elbow) in the rear.

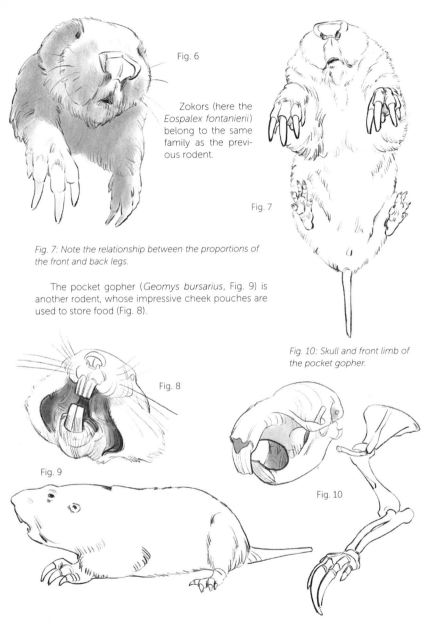

Fig. 6

Zokors (here the *Eospalex fontanierii*) belong to the same family as the previous rodent.

Fig. 7

Fig. 7: Note the relationship between the proportions of the front and back legs.

The pocket gopher (*Geomys bursarius*, Fig. 9) is another rodent, whose impressive cheek pouches are used to store food (Fig. 8).

Fig. 10: Skull and front limb of the pocket gopher.

Fig. 8

Fig. 9

Fig. 10

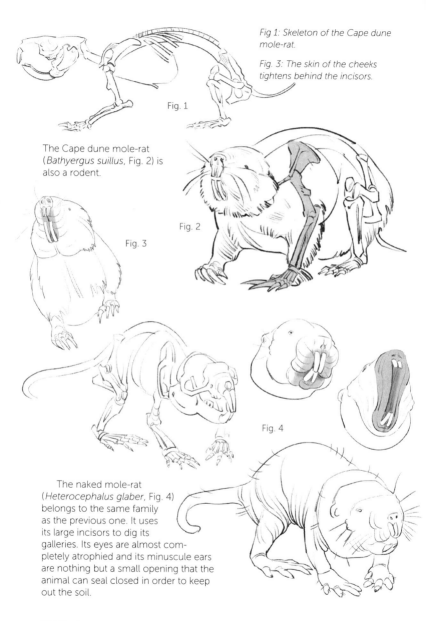

Fig 1: Skeleton of the Cape dune mole-rat.

Fig. 3: The skin of the cheeks tightens behind the incisors.

Fig. 1

The Cape dune mole-rat (*Bathyergus suillus*, Fig. 2) is also a rodent.

Fig. 3

Fig. 2

Fig. 4

The naked mole-rat (*Heterocephalus glaber*, Fig. 4) belongs to the same family as the previous one. It uses its large incisors to dig its galleries. Its eyes are almost completely atrophied and its minuscule ears are nothing but a small opening that the animal can seal closed in order to keep out the soil.

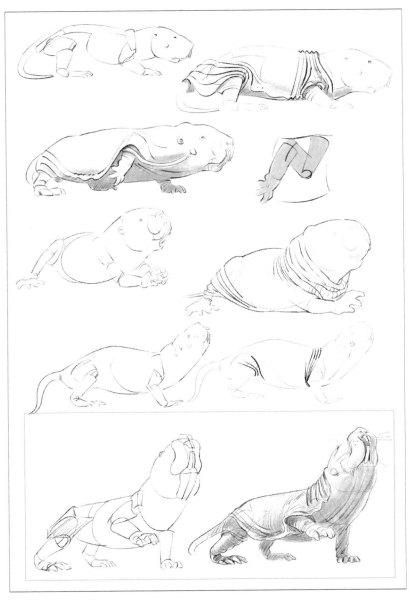

We can distinguish the burrowers, which we have just looked at, from the diggers. The diggers tend to live more on the surface of the ground than underneath it, and they dig to feed themselves and/or to hollow out their nest or den in the ground, sometimes only to hibernate there. But what we will see again here in this series are the powerful front end and the modified extremities.

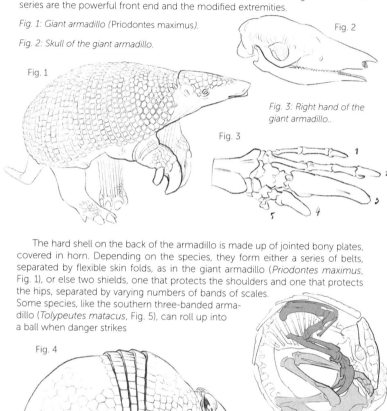

*Fig. 1: Giant armadillo (*Priodontes maximus*).*

Fig. 2: Skull of the giant armadillo.

Fig. 2

Fig. 1

Fig. 3: Right hand of the giant armadillo..

Fig. 3

1

2

3

5

4

The hard shell on the back of the armadillo is made up of jointed bony plates, covered in horn. Depending on the species, they form either a series of belts, separated by flexible skin folds, as in the giant armadillo (*Priodontes maximus*, Fig. 1), or else two shields, one that protects the shoulders and one that protects the hips, separated by varying numbers of bands of scales.

Some species, like the southern three-banded armadillo (*Tolypeutes matacus*, Fig. 5), can roll up into a ball when danger strikes

Fig. 4

Fig. 5

Fig. 6

*Fig. 4 and 5: Southern three-banded armadillo (*Tolypeutes matacus*).*
Fig. 6: Right hand of the southern three-banded armadillo.

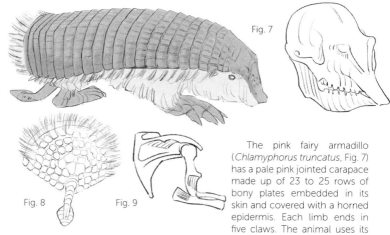

The pink fairy armadillo (*Chlamyphorus truncatus*, Fig. 7) has a pale pink jointed carapace made up of 23 to 25 rows of bony plates embedded in its skin and covered with a horned epidermis. Each limb ends in five claws. The animal uses its front paws to dig the soil, supported by its hind legs and its rigid tail (Fig. 8). Note the size of its shoulder blade, which testifies to its muscular strength (Fig. 9).

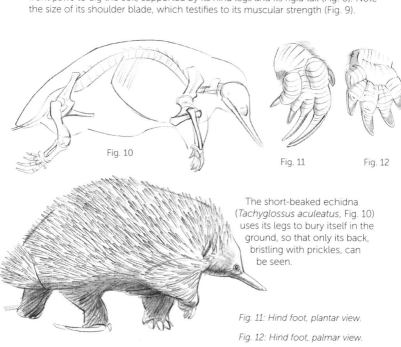

The short-beaked echidna (*Tachyglossus aculeatus*, Fig. 10) uses its legs to bury itself in the ground, so that only its back, bristling with prickles, can be seen.

Fig. 11: Hind foot, plantar view.

Fig. 12: Hind foot, palmar view.

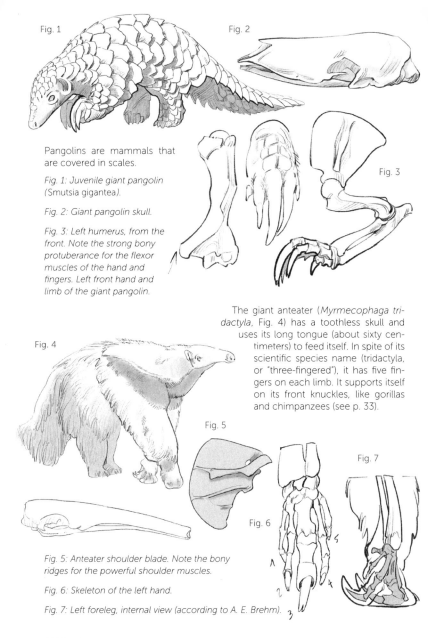

Pangolins are mammals that are covered in scales.

Fig. 1: Juvenile giant pangolin (Smutsia gigantea).

Fig. 2: Giant pangolin skull.

Fig. 3: Left humerus, from the front. Note the strong bony protuberance for the flexor muscles of the hand and fingers. Left front hand and limb of the giant pangolin.

The giant anteater (*Myrmecophaga tridactyla*, Fig. 4) has a toothless skull and uses its long tongue (about sixty centimeters) to feed itself. In spite of its scientific species name (tridactyla, or "three-fingered"), it has five fingers on each limb. It supports itself on its front knuckles, like gorillas and chimpanzees (see p. 33).

Fig. 5: Anteater shoulder blade. Note the bony ridges for the powerful shoulder muscles.

Fig. 6: Skeleton of the left hand.

Fig. 7: Left foreleg, internal view (according to A. E. Brehm).

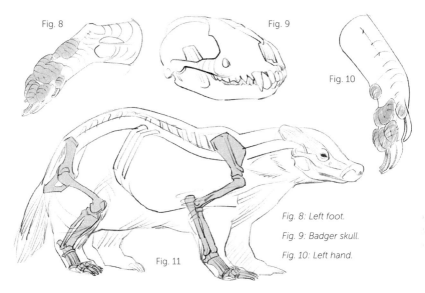

Fig. 8

Fig. 9

Fig. 10

Fig. 11

Fig. 8: Left foot.

Fig. 9: Badger skull.

Fig. 10: Left hand.

The powerful claws of the European badger (*Meles meles*, Fig. 11) make it an excellent digger.

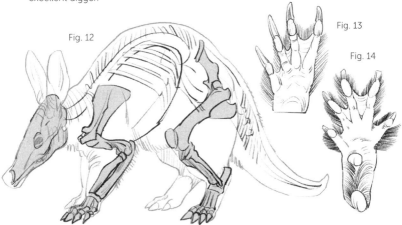

Fig. 12

Fig. 13

Fig. 14

The aardvark (*Orycteropus afer*, Fig. 12 and double page following) has extremities equipped with four fingers in the front (Fig. 13, palmar view) and five in the back (Fig. 14, plantar view, according to R. I. Pocock), armed with strong claws that are somewhat flattened and shovel-shaped, allowing it to dig the ground or to efficiently excavate a termite mound.

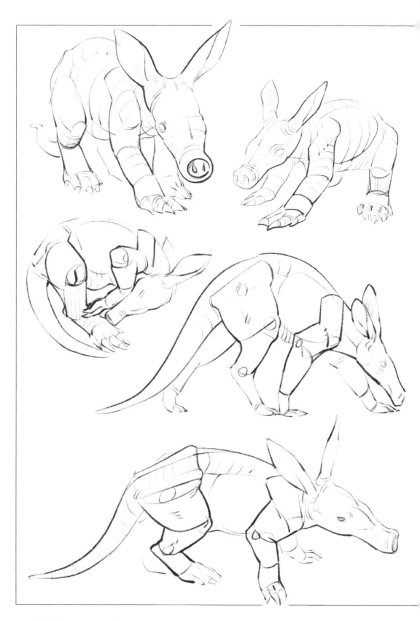

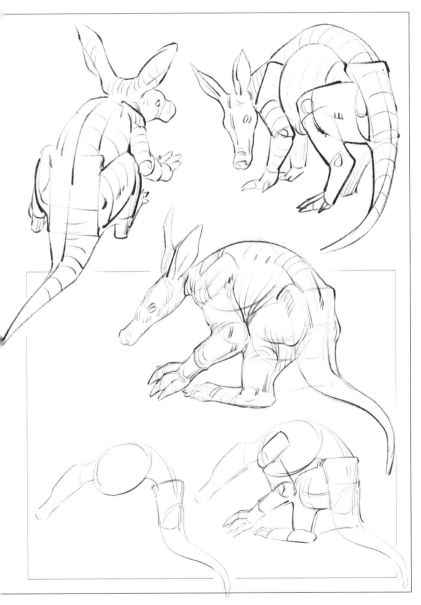

The most efficient way to move fast is to have a long stride, a long distance between supports: in other words, to walk on stilts! Animals that move fast combine two solutions to make this happen: lifting their feet and lengthening their limbs. This lengthening is sometimes accompanied by a simplification of the skeleton (as we shall see a little later, especially on p. 49), making it lighter, but at the same time also causing it to lose all of its other capacities aside from locomotion.

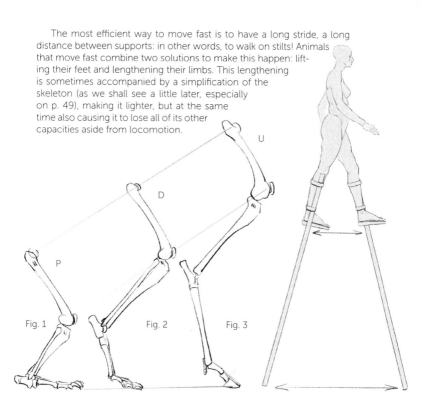

Fig. 1 Fig. 2 Fig. 3

Typically, we distinguish between three main categories of posture and walking:
- Plantigrade locomotion (P) consists of placing the entirety of the foot and hand, including the heel, on the ground. This kind of anchoring provides excellent stability, especially for bipeds like us. This kind of walking can also be found in other species, in this case the bear (Fig. 1).
- Digitigrade locomotion (D) corresponds to our posture when we are on tiptoe (the posture of athletes running a 100-meter race). The heel is thus lifted, as in the wolf shown here (Fig. 2). It will thus become clear why the cheetah holds the record for speed.
- Unguligrade locomotion (U) corresponds to the posture of dancers dancing on point. In this case, the animals only touch the ground with their nail (or hoof). This posture is very well-suited to moving on dry terrain. In this group we will find animals that combine speed and endurance, like the gazelle (Fig. 3).

Of course, as one might expect, there are sometimes exceptions that fall outside of these three broad categories. Elephants, for example, have exposed nails and appear to walk on the tip of their toes. But once we take into account the thick rolls of fat that they have underneath their feet, we can see that in fact the weight transfer takes place further back, below the ankle.

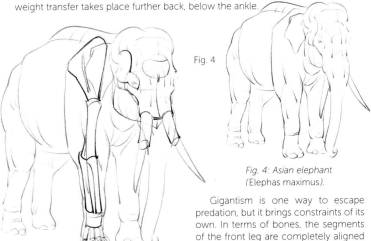

Fig. 4

Fig. 4: Asian elephant (Elephas maximus).

Gigantism is one way to escape predation, but it brings constraints of its own. In terms of bones, the segments of the front leg are completely aligned and form a robust column. The skeleton takes the animal's weight. If you compare all the other quadrupedal postures in this book, you will see that the limbs are usually in a state of dynamic flexion, even at rest.

Elephants are endurance walkers: when they "run" (or move at their fastest pace), it looks like a brisk walk.

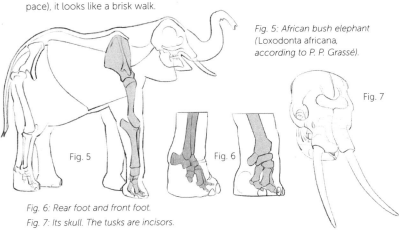

Fig. 5: African bush elephant (Loxodonta africana, according to P. P. Grassé).

Fig. 7

Fig. 5

Fig. 6

Fig. 6: Rear foot and front foot.
Fig. 7: Its skull. The tusks are incisors.

We humans (*Homo sapiens*, Fig. 1) are thus plantigrade bipeds: we walk with our heels completely resting on the ground. A plumb line can be drawn straight down from the center of our skull, behind our lumbar vertebrae, between our femur and patella, and landing at the top of the plantar arch.

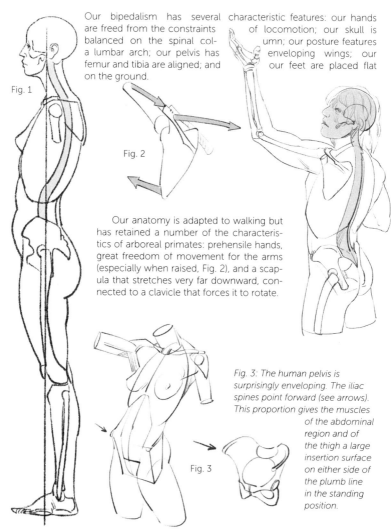

Our bipedalism has several characteristic features: our hands are freed from the constraints of locomotion; our skull is balanced on the spinal col- umn; our posture features a lumbar arch; our pelvis has enveloping wings; our femur and tibia are aligned; and our feet are placed flat on the ground.

Fig. 1

Fig. 2

Our anatomy is adapted to walking but has retained a number of the characteris- tics of arboreal primates: prehensile hands, great freedom of movement for the arms (especially when raised, Fig. 2), and a scap- ula that stretches very far downward, con- nected to a clavicle that forces it to rotate.

Fig. 3: The human pelvis is surprisingly enveloping. The iliac spines point forward (see arrows). This proportion gives the muscles of the abdominal region and of the thigh a large insertion surface on either side of the plumb line in the standing position.

Fig. 3

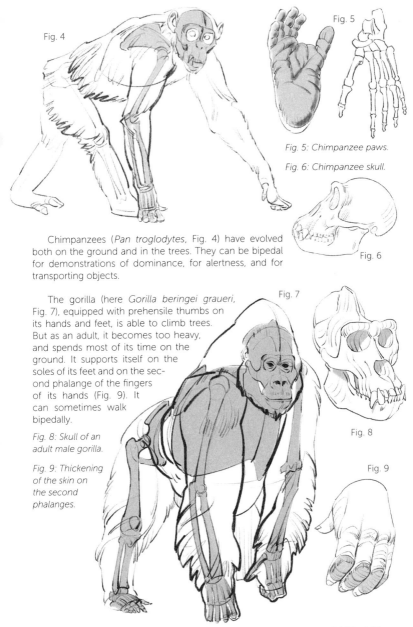

Fig. 4

Fig. 5

Fig. 5: Chimpanzee paws.

Fig. 6: Chimpanzee skull.

Fig. 6

Chimpanzees (*Pan troglodytes*, Fig. 4) have evolved both on the ground and in the trees. They can be bipedal for demonstrations of dominance, for alertness, and for transporting objects.

The gorilla (here *Gorilla beringei graueri*, Fig. 7), equipped with prehensile thumbs on its hands and feet, is able to climb trees. But as an adult, it becomes too heavy, and spends most of its time on the ground. It supports itself on the soles of its feet and on the second phalange of the fingers of its hands (Fig. 9). It can sometimes walk bipedally.

Fig. 7

Fig. 8: Skull of an adult male gorilla.

Fig. 9: Thickening of the skin on the second phalanges.

Fig. 8

Fig. 9

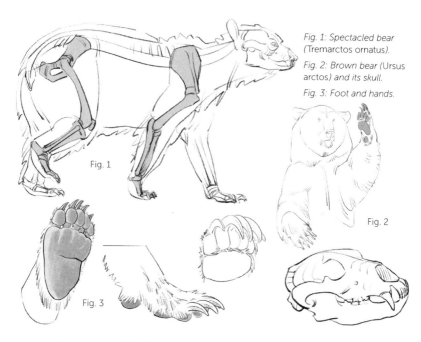

Fig. 1: Spectacled bear (Tremarctos ornatus).

Fig. 2: Brown bear (Ursus arctos) and its skull.

Fig. 3: Foot and hands.

The members of the bear family exhibit many different abilities, from the sun bear, which loves to climb trees, to the polar bear, which is an excellent swimmer. All of these massive plantigrade animals are excellent walkers. The five fingers of their hands are aligned and equipped with strong claws. They have fatty pads that dampen shocks and give them a good grip.

The giant panda (*Ailuropoda melanoleuca*, see its skull in Fig. 4) has an extremely singular feature: the vegetarian diet of this species, although it comes from a family of carnivores, has favored the selection of mutations involving the wrist bones. One of these bones plays the role of an opposable "sixth finger" (Fig. 5). Thus, the panda has a prehensile claw, a fine example of evolutionary "tinkering."

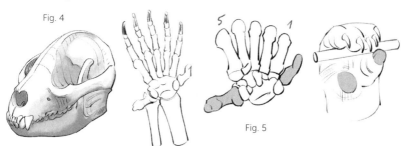

Fig. 4

Fig. 5

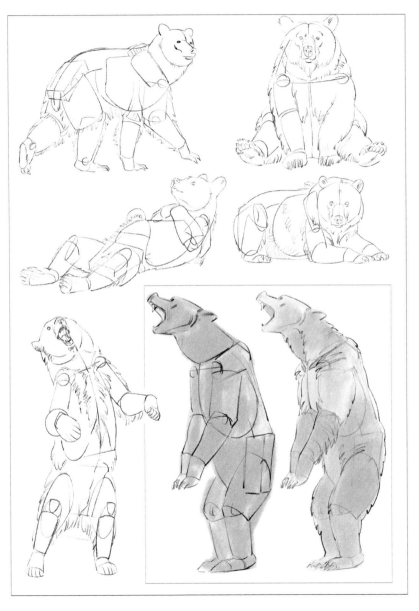

The ermine (*Mustela erminea*, Fig. 1) belongs to the mustelidae family, which has a variety of shapes and behaviors. We have already seen the burrowing badger (p. 27), and later we will see the sea otter (p. 81). The ermine's coat molts over the course of the year: its brown fur becomes white in the winter, making it invisible against the snow. It can easily stand by leaning on its heels.

Fig. 2

Fig. 2: Ermine skull.

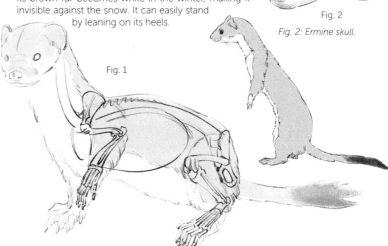

Fig. 1

The common genet (*Genetta genetta*, Fig. 4) is an excellent climber, and mainly hunts on the ground. This member of the civet family has the ability to sneak along silently; its posture then combines plantigrade locomotion in the front with digitigrade locomotion in the back.

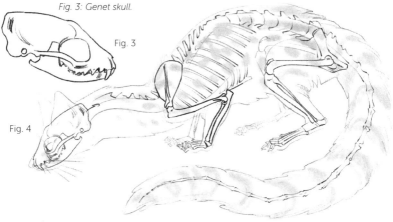

Fig. 3: Genet skull.

Fig. 3

Fig. 4

The wolf (*Canis lupus*, Fig. 5) is the basis for all breeds of dog.

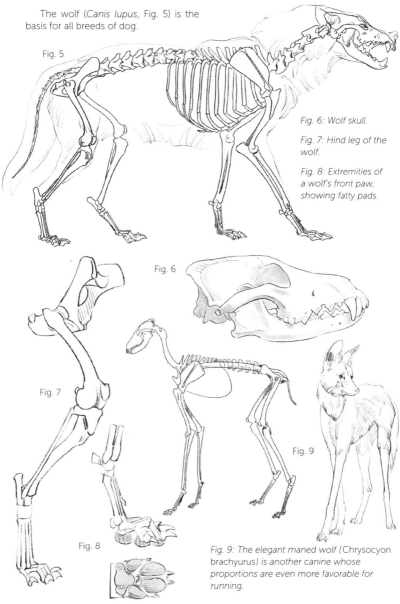

Fig. 5

Fig. 6: Wolf skull.

Fig. 7: Hind leg of the wolf.

Fig. 8: Extremities of a wolf's front paw, showing fatty pads.

Fig. 6

Fig. 7

Fig. 8

Fig. 9

Fig. 9: The elegant maned wolf (Chrysocyon brachyurus) is another canine whose proportions are even more favorable for running.

On this spread we present the felines. The typical feline (striped or spotted) is a hunter, always on the lookout, able to leap and climb trees, armed with murderous jaws and permanently sharpened retractable claws.

*Fig. 1: Tiger (*Panthera tigris*).*

Fig. 2: Tiger skull and diagram of the notch reserved for the lower canine.

Unlike other felines, which tend to be solitary, the lioness (*Panthera leo*, Fig. 3, according to W. Ellenberger) lives and hunts in groups.

Fig. 4: There is an elastic ligament opposite the tendon of the flexors.

Fig. 5: Forepaw of the lioness. Note the position of the claws.

The African wildcat (*Felis silvestris lybica*, Fig. 6), subspecies of the wildcat (*Felis silvestris*), might be the ancestor of our domestic cats. The shortened jaw of felines, with its pincer action, can only perform vertical movements. The teeth, which are reduced in number and highly specialized, are for stabbing (the canines) and shearing (the carnassials).

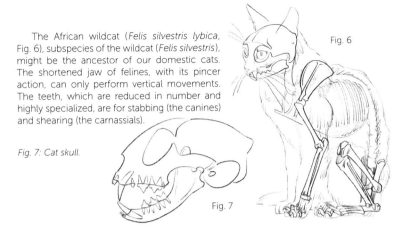

Fig. 6

Fig. 7: Cat skull.

Fig. 7

The cheetah (*Acinonyx jubatus*, Fig. 8) is an atypical feline. What it is lacking in muscular strength (and therefore in weight) it makes up for in speed. Its claws are not retractable, and it chokes its prey at the end of a sprinting race. Its long legs, its absence of a clavicle, and the great flexibility of its spinal column (this animal can double over while running because its strictly carnivorous diet allows it to have a very small abdomen) allow it to compete with gazelles in races over short distances.

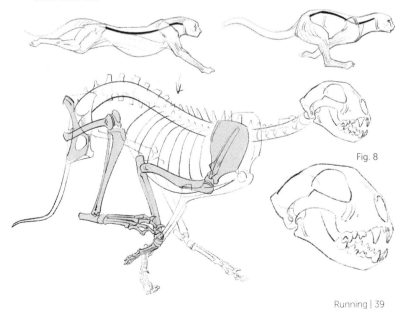

Fig. 8

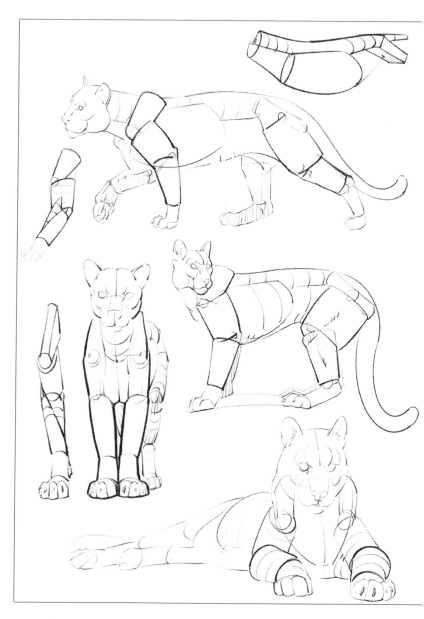

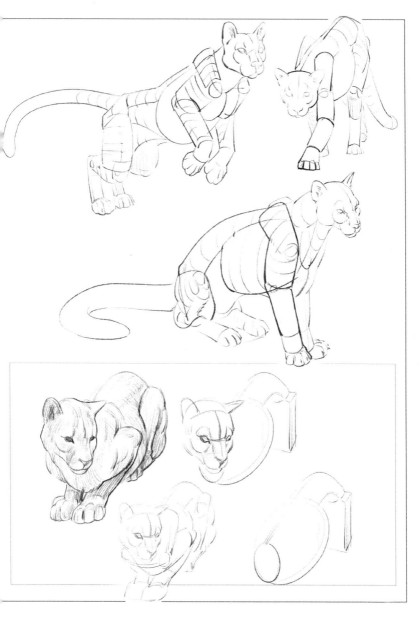

In the case of the ungulates (hoofed mammals), we can sometimes see a reduction in the number of fingers or toes on the hand as well as on the foot (see p. 30). It is interesting to look at how they distribute their weight on these extremities. Perissodactyls put their weight on the axis of the third toe; artiodactyls put it between the second and third toes.

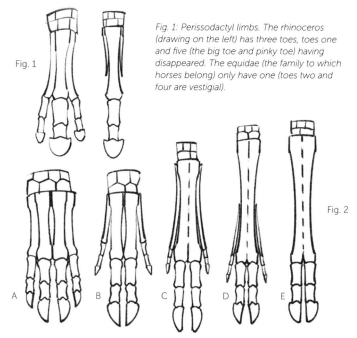

Fig. 1

Fig. 1: Perissodactyl limbs. The rhinoceros (drawing on the left) has three toes, toes one and five (the big toe and pinky toe) having disappeared. The equidae (the family to which horses belong) only have one (toes two and four are vestigial).

Fig. 2

A B C D E

Fig. 2: Artiodactyl limbs. Hippopotamus (A), wild boar (B), mouse deer (C), deer (D), and buffalo (E).

The four toes of the hippopotamus rest on the ground (the big toe has disappeared).

In this series of drawings, the side fingers have been so reduced that they disappear. The two main metas end up fusing (dotted lines) in order to form one single bone (the cannon bone).

There are many species that do not have the same number of toes on their front and back paws. The domestic cat, like all felines, does have five toes in the front, but only has four in the back. This reduction in the back can be found in many species that run (such as the wolf, p. 37); conversely, in several climbing species (such as the two-toed sloth, p. 69), we find a more pronounced reduction in the front.

Tapirs have four toes in the front and three in the back. The middle finger of the tapir's hand is stronger, because it puts its weight on its axis; this makes the tapir a perissodactyl, even though it has an even number of digits.

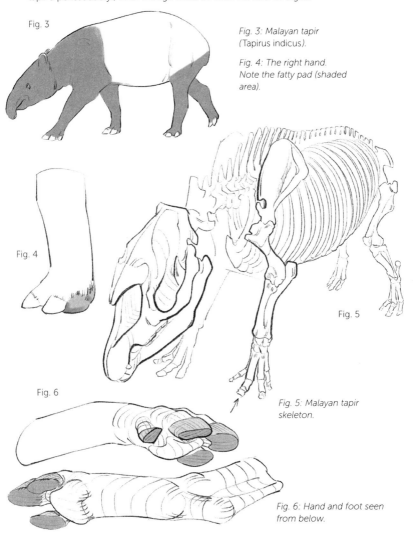

Fig. 3

Fig. 3: Malayan tapir (Tapirus indicus).

Fig. 4: The right hand. Note the fatty pad (shaded area).

Fig. 4

Fig. 5

Fig. 6

Fig. 5: Malayan tapir skeleton.

Fig. 6: Hand and foot seen from below.

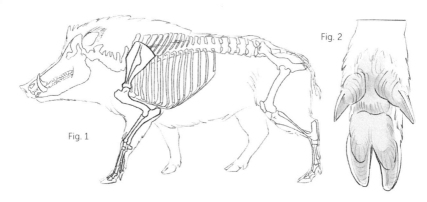

Fig. 1

Fig. 2

Suidae (commonly called pigs, hogs, or swine) are artiodactyls whose paws have four claws. The domestic pig is derived from the domestication of the wild boar (*Sus scrofa*, Fig. 1, according to Pales and Garcia), an omnivore with powerful forequarters, a massive neck, and a conical head. Its lower canines, which never stop growing, are developed into tusks, and sharpened in contact with the upper canines.

Fig. 2: Wild boar paw. The split hoof, supported by the two toes, can spread; taken together with the two claws wedged onto the vestigial digits, this can prevent the animal from getting bogged down in overly soft ground.

The common warthog (*Phacochoerus africanus*, Fig. 3) has two tusks (this is true of both the male and the female) that point upwards and can be as much as 60 centimeters long in old animals. It uses its tusks to dig up roots and bulbs and for self-defense against its predators, which it usually escapes through its ability to run.

The upper canines of the male babirusa (*Babyrousa babyrussa*, Fig. 4, according to Guillemard) push upward, piercing the skin and curling backward so far that they sometimes penetrate the skin of the forehead.

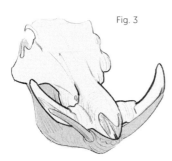

Fig. 3

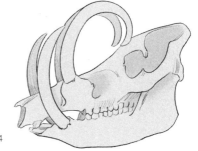

Fig. 4

The red deer (*Cervus elaphus*, Fig. 5 and 7) is a ruminant artiodactyl, which therefore shares some characteristics with the bovines (see following pages). These animals support themselves on two toes that are jointed with two fused metas (Fig. 8, shaded area). Their skull has no incisors in the upper jaw, which has a long gap without any teeth between the lower incisors and the (pre)molars.

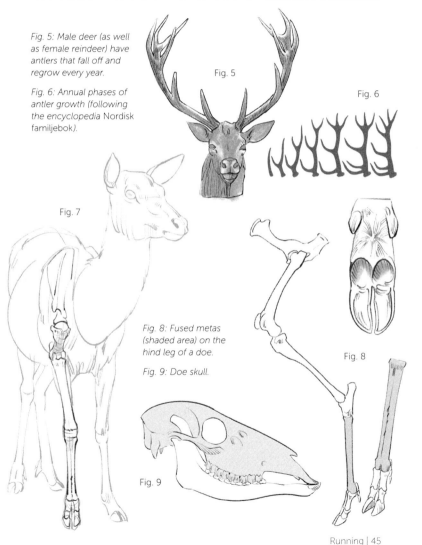

Fig. 5: Male deer (as well as female reindeer) have antlers that fall off and regrow every year.

Fig. 6: Annual phases of antler growth (following the encyclopedia Nordisk familjebok).

Fig. 5

Fig. 6

Fig. 7

Fig. 8: Fused metas (shaded area) on the hind leg of a doe.

Fig. 9: Doe skull.

Fig. 8

Fig. 9

The classification of bovines (a family of ruminant artiodactyl mammals) is rather complex. It includes many species whose categorization into subfamilies is a matter of debate within the scientific community.

To simplify, we will talk about them in terms of bovines (domestic cows and bison, Fig. 1, for example), caprines (goats and sheep), and the animals that are commonly called antelopes.

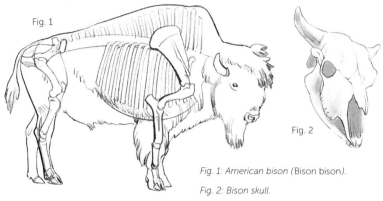

Fig. 1

Fig. 2

Fig. 1: American bison (Bison bison).

Fig. 2: Bison skull.

Fig. 3: Bovine forelimb, from the front and from the side.

Fig. 4: Oribi (Ourebia ourebi). This is considered an antelope, but "antelope" is a term used in common language that does not correspond to any scientifically designated natural taxonomic group.

The nilgai antelope (Boselaphus tragocamelus), shown on the righthand page, is a bovine.

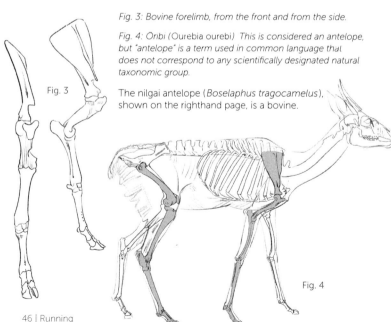

Fig. 3

Fig. 4

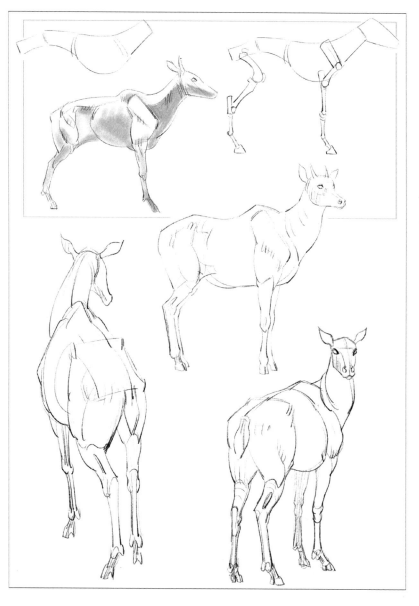

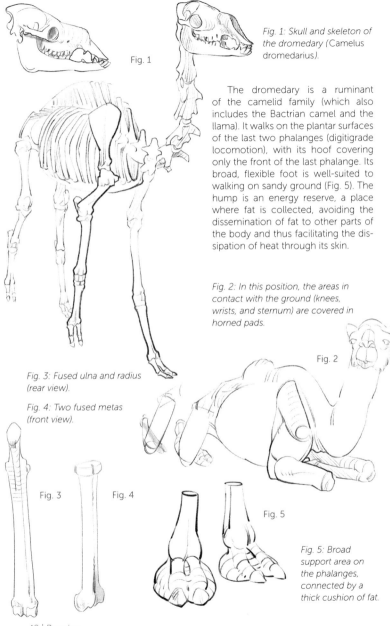

Fig. 1: Skull and skeleton of the dromedary (Camelus dromedarius).

The dromedary is a ruminant of the camelid family (which also includes the Bactrian camel and the llama). It walks on the plantar surfaces of the last two phalanges (digitigrade locomotion), with its hoof covering only the front of the last phalange. Its broad, flexible foot is well-suited to walking on sandy ground (Fig. 5). The hump is an energy reserve, a place where fat is collected, avoiding the dissemination of fat to other parts of the body and thus facilitating the dissipation of heat through its skin.

Fig. 2: In this position, the areas in contact with the ground (knees, wrists, and sternum) are covered in horned pads.

Fig. 3: Fused ulna and radius (rear view).

Fig. 4: Two fused metas (front view).

Fig. 5: Broad support area on the phalanges, connected by a thick cushion of fat.

Fig. 1

Fig. 2

Fig. 3

Fig. 4

Fig. 5

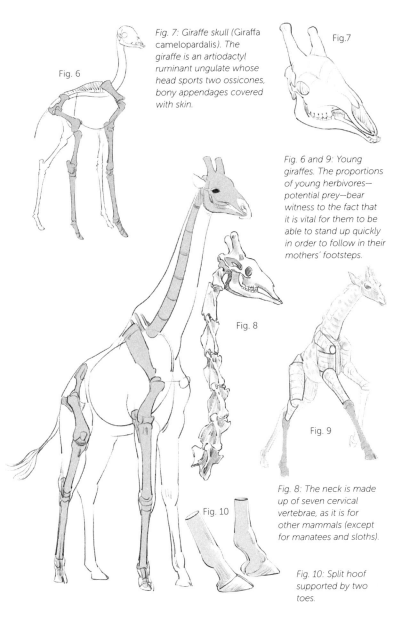

Fig. 7: Giraffe skull (Giraffa camelopardalis). The giraffe is an artiodactyl ruminant ungulate whose head sports two ossicones, bony appendages covered with skin.

Fig. 6

Fig.7

Fig. 6 and 9: Young giraffes. The proportions of young herbivores—potential prey—bear witness to the fact that it is vital for them to be able to stand up quickly in order to follow in their mothers' footsteps.

Fig. 8

Fig. 9

Fig. 8: The neck is made up of seven cervical vertebrae, as it is for other mammals (except for manatees and sloths).

Fig. 10

Fig. 10: Split hoof supported by two toes.

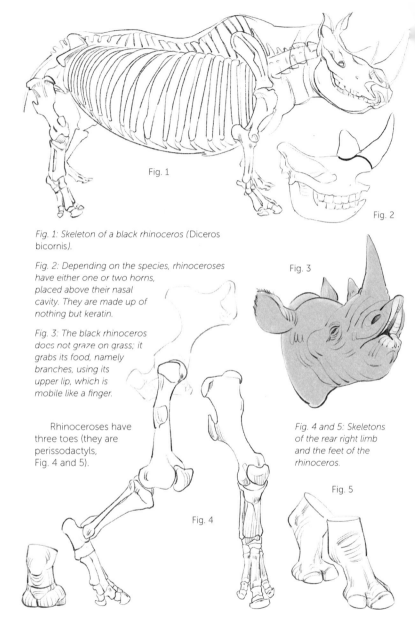

Fig. 1

Fig. 2

Fig. 1: Skeleton of a black rhinoceros (Diceros bicornis).

Fig. 2: Depending on the species, rhinoceroses have either one or two horns, placed above their nasal cavity. They are made up of nothing but keratin.

Fig. 3: The black rhinoceros does not graze on grass; it grabs its food, namely branches, using its upper lip, which is mobile like a finger.

Fig. 3

Rhinoceroses have three toes (they are perissodactyls, Fig. 4 and 5).

Fig. 4 and 5: Skeletons of the rear right limb and the feet of the rhinoceros.

Fig. 5

Fig. 4

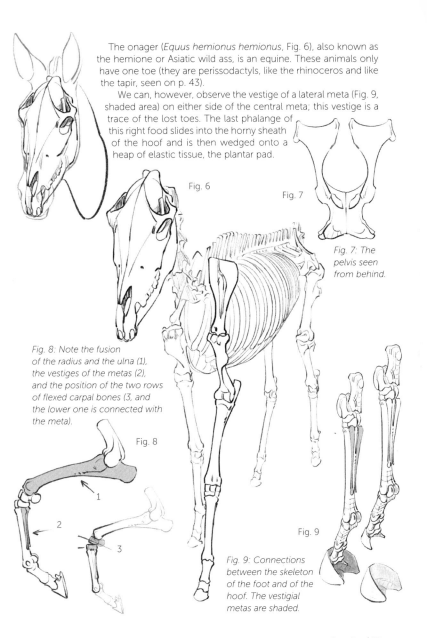

The onager (*Equus hemionus hemionus*, Fig. 6), also known as the hemione or Asiatic wild ass, is an equine. These animals only have one toe (they are perissodactyls, like the rhinoceros and like the tapir, seen on p. 43).

We can, however, observe the vestige of a lateral meta (Fig. 9, shaded area) on either side of the central meta; this vestige is a trace of the lost toes. The last phalange of this right food slides into the horny sheath of the hoof and is then wedged onto a heap of elastic tissue, the plantar pad.

Fig. 6

Fig. 7

Fig. 7: The pelvis seen from behind.

Fig. 8: Note the fusion of the radius and the ulna (1), the vestiges of the metas (2), and the position of the two rows of flexed carpal bones (3, and the lower one is connected with the meta).

Fig. 8

Fig. 9

Fig. 9: Connections between the skeleton of the foot and of the hoof. The vestigial metas are shaded.

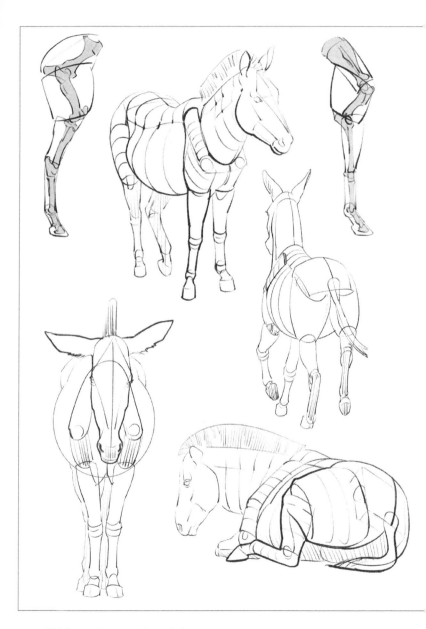

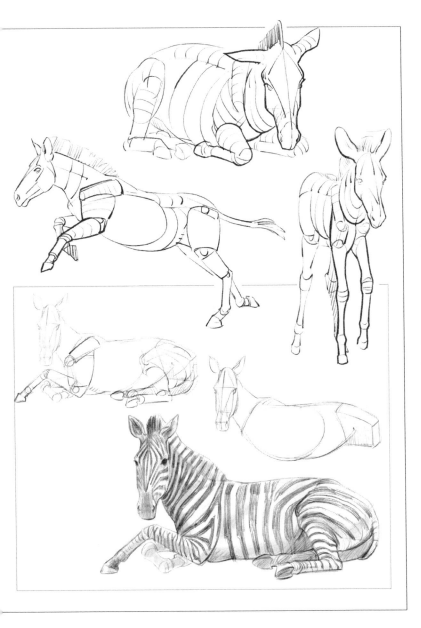

Animals that jump have long, powerful hind legs, just as we might expect. Even though their hyperdeveloped feet predispose them to bipedalism, their posture is mostly tilted towards the front, a result of their quadrupedal history. In these drawings, we therefore see a problem of balance, which is solved by the atrophy of their front limbs, complemented and balanced by the existence of a long tail (Fig. 1).

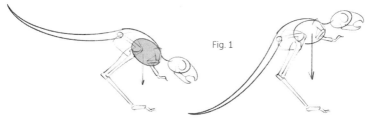

Fig. 1: In small specimens, like the jerboa seen here, the head is still relatively large because it has to accommodate the brain, the sense organs, and the jaw, which needs to remain powerful. It is the front legs that bear more of the necessity of weight reduction in the front. They lose their locomotive role and become auxiliaries to the jaw.

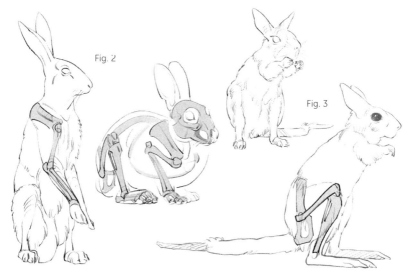

Fig. 2: The European hare, or brown hare (Lepus europaeus), is not a rodent but a lagomorph.

Fig. 3: The South African springhare (Pedetes capensis), on the other hand, is indeed a rodent!

The name "jerboa" is used to refer collectively to several species of rodent mammals with large hind legs.

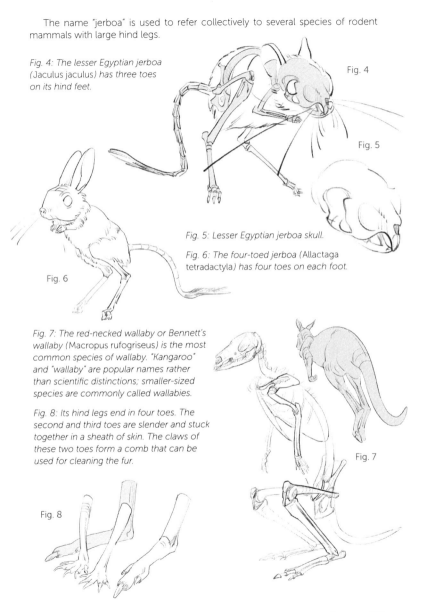

Fig. 4: *The lesser Egyptian jerboa* (Jaculus jaculus) *has three toes on its hind feet.*

Fig. 4

Fig. 5

Fig. 5: *Lesser Egyptian jerboa skull.*

Fig. 6: *The four-toed jerboa (*Allactaga tetradactyla*) has four toes on each foot.*

Fig. 6

Fig. 7: *The red-necked wallaby or Bennett's wallaby (*Macropus rufogriseus*) is the most common species of wallaby. "Kangaroo" and "wallaby" are popular names rather than scientific distinctions; smaller-sized species are commonly called wallabies.*

Fig. 8: *Its hind legs end in four toes. The second and third toes are slender and stuck together in a sheath of skin. The claws of these two toes form a comb that can be used for cleaning the fur.*

Fig. 7

Fig. 8

For humans, climbing shoes arch the feet and allow us to use the reinforced toe in order to grab onto the smallest protrusion. Ungulates' hooves, which are adapted to running on dry terrain, as we have seen, are also well-suited to the needs of climbing species: mountain goats and chamois antelopes are evidence of this.

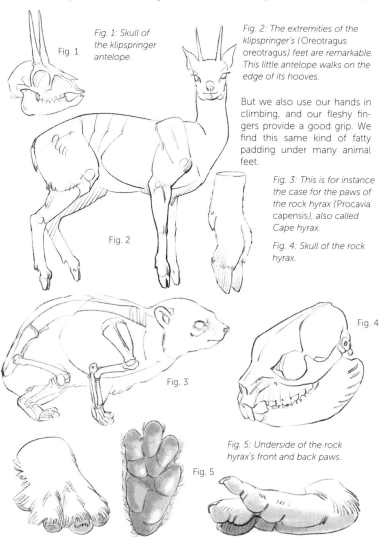

Fig. 1: Skull of the klipspringer antelope.

Fig. 1

Fig. 2: The extremities of the klipspringer's (Oreotragus oreotragus) feet are remarkable. This little antelope walks on the edge of its hooves.

But we also use our hands in climbing, and our fleshy fingers provide a good grip. We find this same kind of fatty padding under many animal feet.

Fig. 3: This is for instance the case for the paws of the rock hyrax (Procavia capensis), also called Cape hyrax.

Fig. 4: Skull of the rock hyrax.

Fig. 2

Fig. 3

Fig. 4

Fig. 5: Underside of the rock hyrax's front and back paws.

Fig. 5

Climbing trees requires the same adaptations, as well as claws (for hooking onto tree bark), a possible opposition of the fingers/toes of the hands and feet (for holding onto branches), and a tail (prehensile or simply for balance).

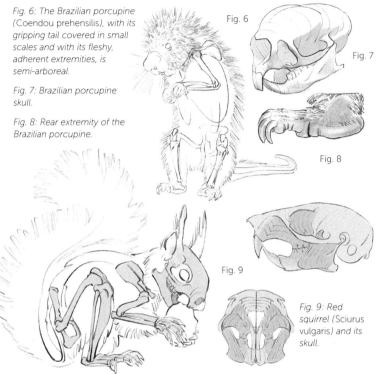

Fig. 6: The Brazilian porcupine (Coendou prehensilis), with its gripping tail covered in small scales and with its fleshy, adherent extremities, is semi-arboreal.

Fig. 7: Brazilian porcupine skull.

Fig. 8: Rear extremity of the Brazilian porcupine.

Fig. 6

Fig. 7

Fig. 8

Fig. 9

Fig. 9: Red squirrel (Sciurus vulgaris) and its skull.

Fig. 10: The large tree shrew (Tupaia tana) is another good example of evolutionary convergence. This species is not a rodent but a member of the Scandentia order, like the pen-tailed tree shrew (Ptilocercus lowii) presented on p. 59, and the way it moves in the trees evokes a squirrel's movements.

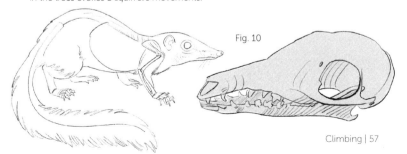

Fig. 10

This page illustrates, once again, the effects of evolutionary convergence. These species belong to different orders, but they all have prehensile extremities.

*Fig. 1: The Atlantic or southern bamboo rat (*Kannabateomys amblyonyx*) is a rodent that is very good at climbing. Notice the axis of the foot (Fig. 2): three of the toes are opposed to the other two, in order to form a claw. On the hand, the fingers are opposed two against two (Fig. 3).*

Fig. 1

Fig. 2

Fig. 3

American marsupials display excellent adaptations to arboreal life. Here we see the monito del monte, or colocolo opossum (*Dromiciops gliroides*, Fig. 4), whose grooved pads can be appreciated for their good grip. Note the opposition of the fingers and toes on the branch.

Fig. 4

Fig. 5

Fig. 6

Fig. 5: Colocolo opposum skull.

Fig. 6: Hand and foot of the colocolo opossum.

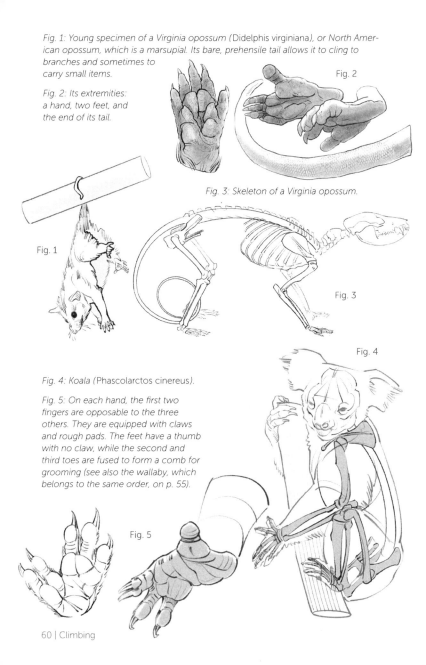

Fig. 1: Young specimen of a Virginia opossum (Didelphis virginiana), or North American opossum, which is a marsupial. Its bare, prehensile tail allows it to cling to branches and sometimes to carry small items.

Fig. 2: Its extremities: a hand, two feet, and the end of its tail.

Fig. 2

Fig. 1

Fig. 3: Skeleton of a Virginia opossum.

Fig. 3

Fig. 4: Koala (Phascolarctos cinereus).

Fig. 4

Fig. 5: On each hand, the first two fingers are opposable to the three others. They are equipped with claws and rough pads. The feet have a thumb with no claw, while the second and third toes are fused to form a comb for grooming (see also the wallaby, which belongs to the same order, on p. 55).

Fig. 5

Fig. 6: The common spotted cuscus, or white cuscus (Spilocuscus maculatus), belongs to the same order as the koala. At rest, its prehensile tail, which is longer than its body and has no hair at the end, is held in a curled-up position. Note the opposition of the fingers and toes.

Fig. 6

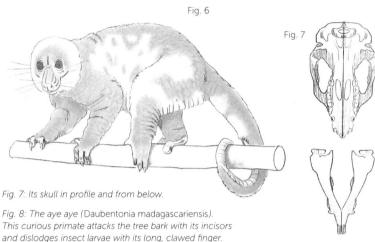

Fig. 7

Fig. 7: Its skull in profile and from below.

Fig. 8: The aye aye (Daubentonia madagascariensis). This curious primate attacks the tree bark with its incisors and dislodges insect larvae with its long, clawed finger.

Fig. 8

Fig. 9

Fig 9: Aye aye skull.

Fig. 10: Aye aye hand and foot.

Fig. 10

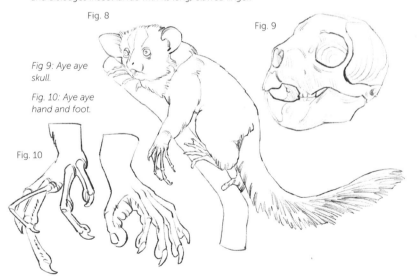

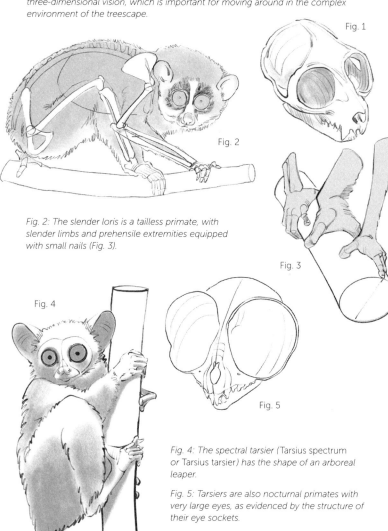

Fig. 1: Skull of the slender loris (Loris tardigradus), nocturnal, with wide eye sockets. Its flat face and eyes brought forward to the front of the head promote three-dimensional vision, which is important for moving around in the complex environment of the treescape.

Fig. 1

Fig. 2

Fig. 2: The slender loris is a tailless primate, with slender limbs and prehensile extremities equipped with small nails (Fig. 3).

Fig. 3

Fig. 4

Fig. 5

Fig. 4: The spectral tarsier (Tarsius spectrum or Tarsius tarsier) has the shape of an arboreal leaper.

Fig. 5: Tarsiers are also nocturnal primates with very large eyes, as evidenced by the structure of their eye sockets.

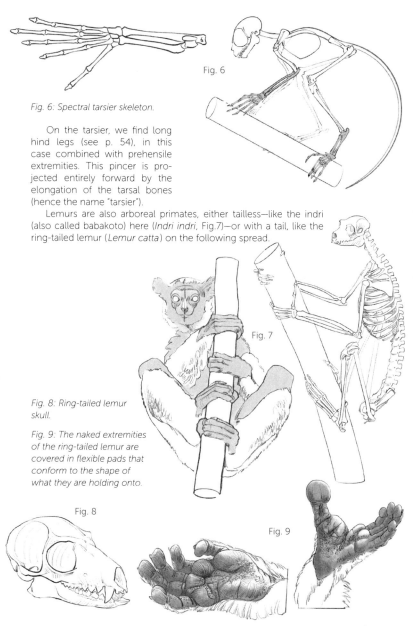

Fig. 6: Spectral tarsier skeleton.

On the tarsier, we find long hind legs (see p. 54), in this case combined with prehensile extremities. This pincer is projected entirely forward by the elongation of the tarsal bones (hence the name "tarsier").

Lemurs are also arboreal primates, either tailless—like the indri (also called babakoto) here (*Indri indri*, Fig.7)—or with a tail, like the ring-tailed lemur (*Lemur catta*) on the following spread.

Fig. 8: Ring-tailed lemur skull.

Fig. 9: The naked extremities of the ring-tailed lemur are covered in flexible pads that conform to the shape of what they are holding onto.

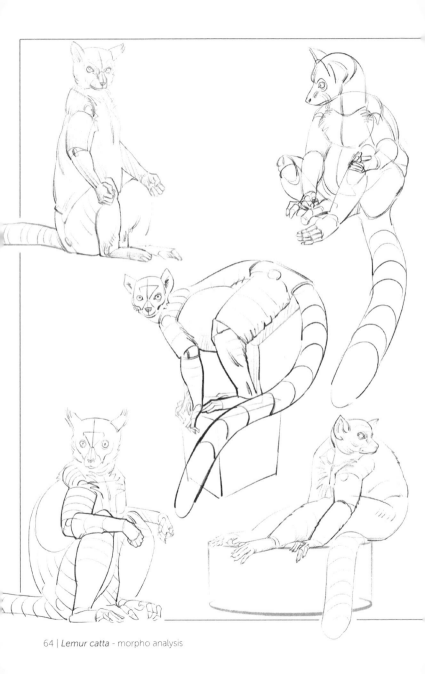

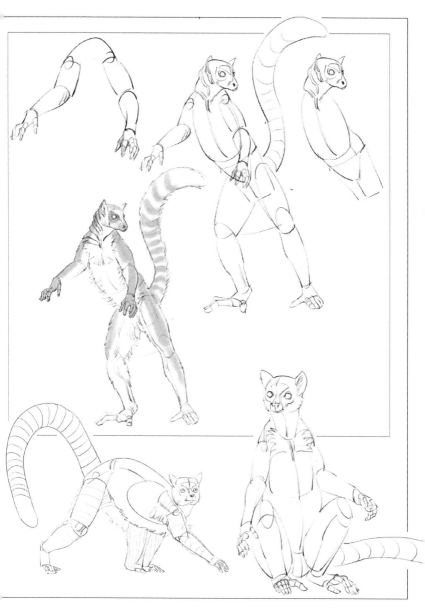

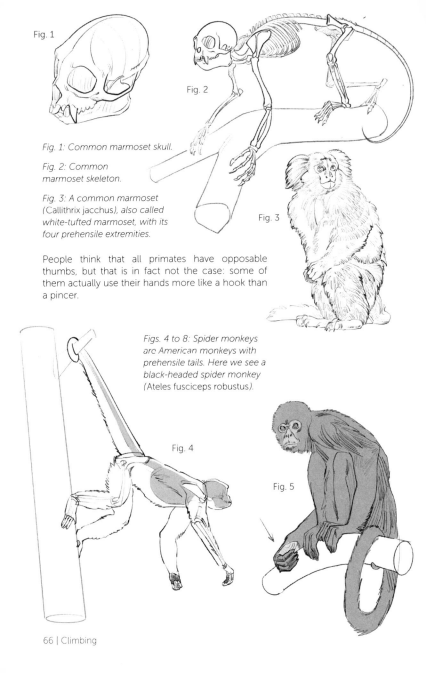

Fig. 1: *Common marmoset skull.*

Fig. 2: *Common marmoset skeleton.*

Fig. 3: *A common marmoset (Callithrix jacchus), also called white-tufted marmoset, with its four prehensile extremities.*

People think that all primates have opposable thumbs, but that is in fact not the case: some of them actually use their hands more like a hook than a pincer.

Figs. 4 to 8: *Spider monkeys are American monkeys with prehensile tails. Here we see a black-headed spider monkey (Ateles fusciceps robustus).*

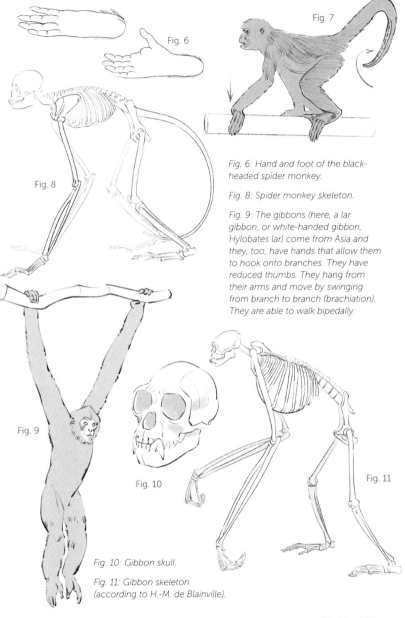

Fig. 6: Hand and foot of the black-headed spider monkey.

Fig. 8: Spider monkey skeleton.

Fig. 9: The gibbons (here, a lar gibbon, or white-handed gibbon, Hylobates lar) come from Asia and they, too, have hands that allow them to hook onto branches. They have reduced thumbs. They hang from their arms and move by swinging from branch to branch (brachiation). They are able to walk bipedally.

Fig. 10: Gibbon skull.

Fig. 11: Gibbon skeleton (according to H.-M. de Blainville).

On the previous spread, we saw hands modified into hooks. But this modification can also be entirely transferred to long, curved claws.

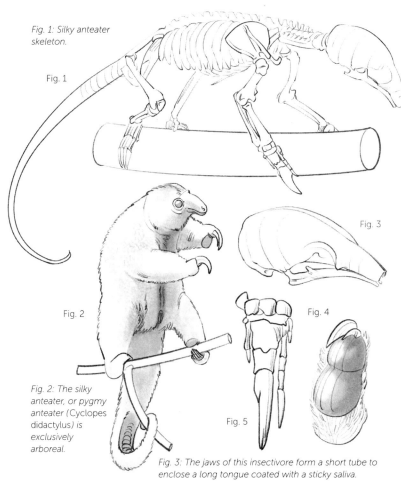

Fig. 1: Silky anteater skeleton.

Fig. 1

Fig. 3

Fig. 2

Fig. 4

Fig. 2: The silky anteater, or pygmy anteater (Cyclopes didactylus) is exclusively arboreal.

Fig. 5

Fig. 3: The jaws of this insectivore form a short tube to enclose a long tongue coated with a sticky saliva.

Fig. 4: Right hand (palm side view). The Latin name of the silky anteater indicates the presence of two fingers on the hands, but it seems to put all its effort into the middle finger, which is much larger. Its claws also allow it to break open anthills and termite mounds.

Fig. 5: Skeleton of the right hand (dorsal view).

There remains the extraordinary case of the sloths. These animals hang from the long claws that they have at the end of each of their limbs. We distinguish between two families of sloths, depending on whether their hands have two toes or three.

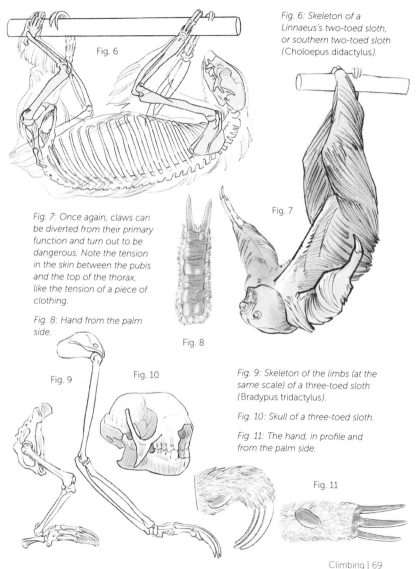

Fig. 6: Skeleton of a Linnaeus's two-toed sloth, or southern two-toed sloth (Choloepus didactylus).

Fig. 6

Fig. 7

Fig. 7: Once again, claws can be diverted from their primary function and turn out to be dangerous. Note the tension in the skin between the pubis and the top of the thorax, like the tension of a piece of clothing.

Fig. 8: Hand from the palm side.

Fig. 8

Fig. 9

Fig. 10

Fig. 9: Skeleton of the limbs (at the same scale) of a three-toed sloth (Bradypus tridactylus).

Fig. 10: Skull of a three-toed sloth.

Fig. 11: The hand, in profile and from the palm side.

Fig. 11

We have just seen the morphologies of arboreal climbers; now it is time to jump into the void! Simple membranes or folds of skin (patagiums) allow small animals to acquire enough of a surface to generate lift and slow their fall (this is the same principle that wingsuits use). Thus, they are able to "glide" through the air from one tree to another.

*Fig. 1: Skeleton of a southern flying squirrel or assapan (*Glaucomys volans*). Note the cartilaginous "spurs" at its wrist, which contribute to the tension in the patagium.*

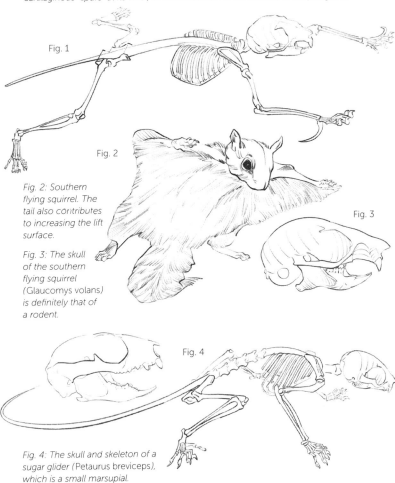

Fig. 1

Fig. 2

Fig. 2: Southern flying squirrel. The tail also contributes to increasing the lift surface.

*Fig. 3: The skull of the southern flying squirrel (*Glaucomys volans*) is definitely that of a rodent.*

Fig. 3

Fig. 4

*Fig. 4: The skull and skeleton of a sugar glider (*Petaurus breviceps*), which is a small marsupial.*

Dermoptera, commonly called flying lemurs (although they are not primates), have all four limbs connected by a membrane (a patagium). Each limb ends in five webbed toes with strong, curved nails, ensuring a good grip on tree bark. Their hands are prehensile.

The order Demoptera has only the two species presented on this spread.

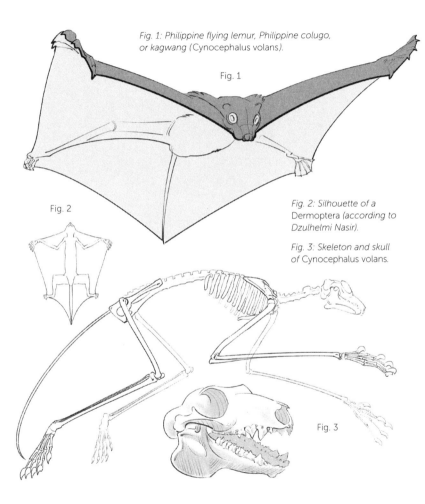

*Fig. 1: Philippine flying lemur, Philippine colugo, or kagwang (*Cynocephalus volans*).*

Fig. 1

Fig. 2

Fig. 2: Silhouette of a Dermoptera (according to Dzulhelmi Nasir).

Fig. 3: Skeleton and skull of Cynocephalus volans.

Fig. 3

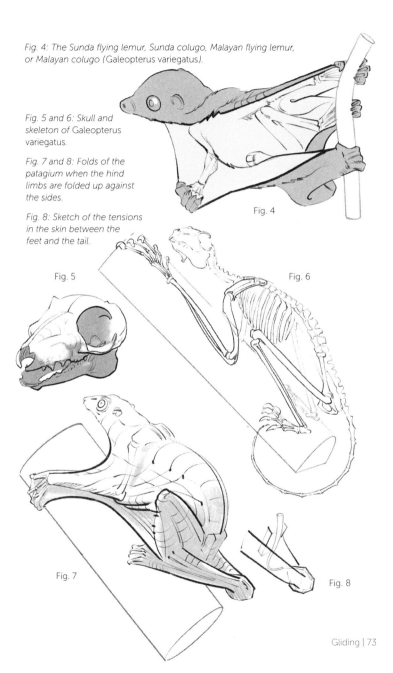

Fig. 4: The Sunda flying lemur, Sunda colugo, Malayan flying lemur, or Malayan colugo (Galeopterus variegatus).

Fig. 5 and 6: Skull and skeleton of Galeopterus variegatus.

Fig. 7 and 8: Folds of the patagium when the hind limbs are folded up against the sides.

Fig. 8: Sketch of the tensions in the skin between the feet and the tail.

Fig. 4

Fig. 5

Fig. 6

Fig. 7

Fig. 8

There are about a thousand different species of Chiroptera, commonly called bats. They are the only mammals capable of active flight, in other words flapping their wings! Most bat species land on the ground only in exceptional circumstances, and prefer to rest suspended by their feet. Their "winged hands" have four hypertrophied fingers connected by a soft, elastic membrane (the patagium). Their thumb is reduced and clawed. The index finger, close to the middle finger, serves as a reinforcement for the wing's leading edge.

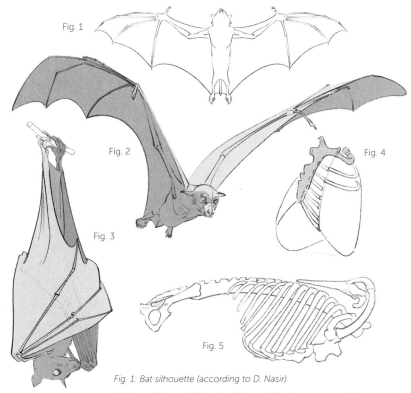

Fig. 1: Bat silhouette (according to D. Nasir).

Fig. 2 and 3: Large flying fox, Malayan flying fox, or large fruit bat (Pteropus vampyrus).

Fig. 4: Ribcage (three-quarter front view). The sternum and the thick first rib are shaded.

Fig. 5: Skeleton of the trunk seen in in profile. A very strong clavicle, a broad scapula, and a streamlined sternum are the areas of insertion for the powerful wing muscles.

The hind legs are fully rotated at the hip, giving the impression of a knee bending backward. The "big toe" is actually on the outside. The hind legs naturally rest on the half dome of the entire bearing surface, or airfoil, when it is unfolded (see various examples on the following spread).

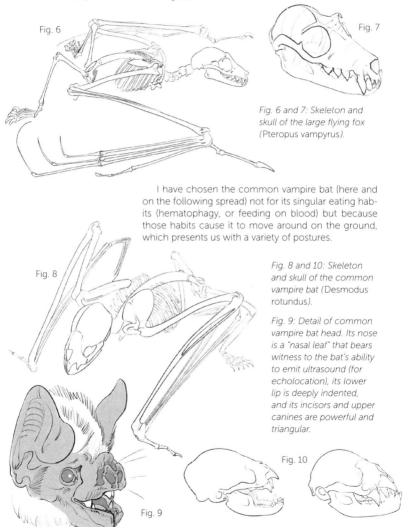

Fig. 6

Fig. 7

*Fig. 6 and 7: Skeleton and skull of the large flying fox (*Pteropus vampyrus*).*

I have chosen the common vampire bat (here and on the following spread) not for its singular eating habits (hematophagy, or feeding on blood) but because those habits cause it to move around on the ground, which presents us with a variety of postures.

Fig. 8

*Fig. 8 and 10: Skeleton and skull of the common vampire bat (*Desmodus rotundus*).*

Fig. 9: Detail of common vampire bat head. Its nose is a "nasal leaf" that bears witness to the bat's ability to emit ultrasound (for echolocation), its lower lip is deeply indented, and its incisors and upper canines are powerful and triangular.

Fig. 10

Fig. 9

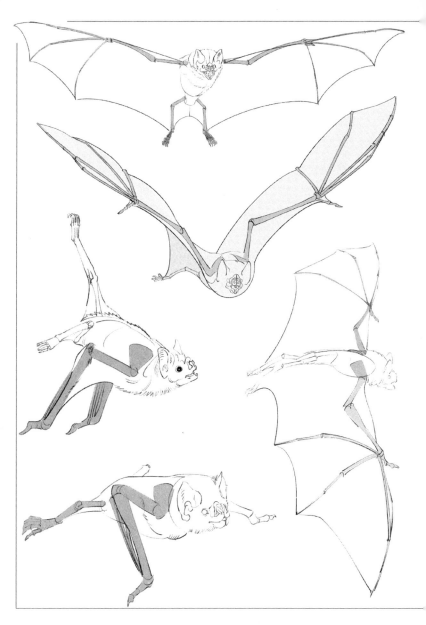

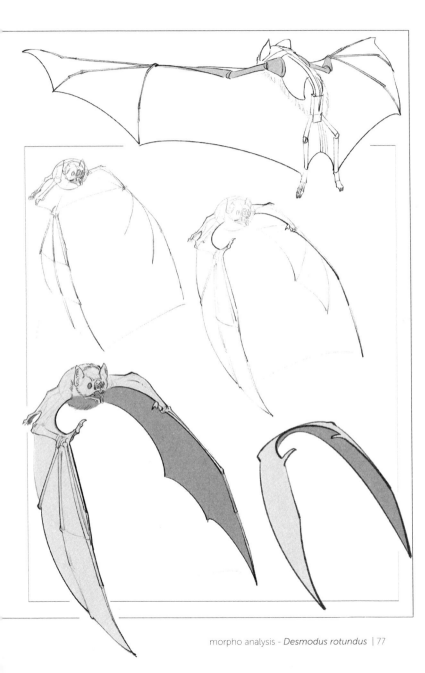

The broad, short wings help in catching arboreal insects. Because they can hover in place, long-eared bats are able to seize their prey directly on the leaves.

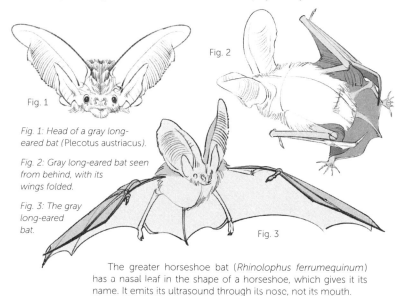

Fig. 1: Head of a gray long-eared bat (Plecotus austriacus).

Fig. 2: Gray long-eared bat seen from behind, with its wings folded.

Fig. 3: The gray long-eared bat.

The greater horseshoe bat (*Rhinolophus ferrumequinum*) has a nasal leaf in the shape of a horseshoe, which gives it its name. It emits its ultrasound through its nose, not its mouth.

Fig. 4: Greater horseshoe bat hanging upside down, wrapped inside its patagium.

Fig. 5: Head and skull of a greater horseshoe bat.

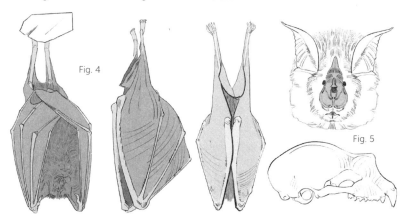

Thyropterans have suction cups at the base of their thumbs and underneath their ankles that allow them to stick to the smooth surface of leaves. Unlike most bats, they hang right-side up.

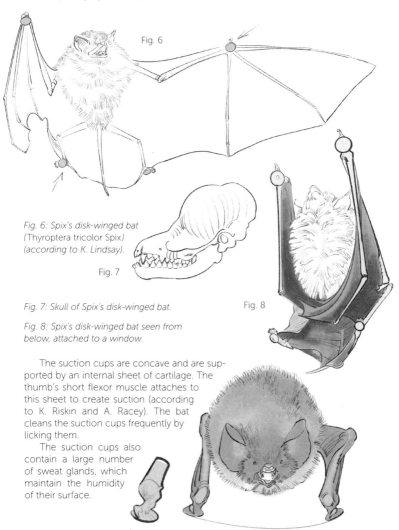

Fig. 6: Spix's disk-winged bat (Thyroptera tricolor Spix) (according to K. Lindsay).

Fig. 7

Fig. 7: Skull of Spix's disk-winged bat.

Fig. 8: Spix's disk-winged bat seen from below, attached to a window.

The suction cups are concave and are supported by an internal sheet of cartilage. The thumb's short flexor muscle attaches to this sheet to create suction (according to K. Riskin and A. Racey). The bat cleans the suction cups frequently by licking them.

The suction cups also contain a large number of sweat glands, which maintain the humidity of their surface.

Finally, we need to analyze the morphology of aquatic mammals, from amphibians to those that live exclusively in the water! We will see a lot of webbed feet, as you might expect, along with simplified silhouettes made hydrodynamic by very dense fur that preserves a layer of air above the skin, or by a fatty layer of insulation that improves buoyancy.

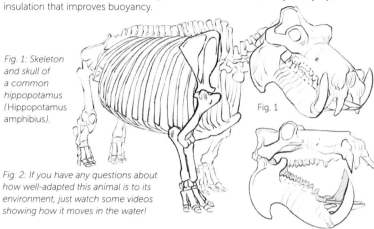

Fig. 1: Skeleton and skull of a common hippopotamus (Hippopotamus amphibius).

Fig. 1

Fig. 2: If you have any questions about how well-adapted this animal is to its environment, just watch some videos showing how it moves in the water!

Hippopotamuses are unguligrades (they walk on hooves), but unlike most other animals of this kind, their weight rests on the pad of hard connective tissue that is present under each of their four feet (Fig. 3, and compare to p. 31).

Fig. 2

Fig. 3

The sea otter (*Enhydra lutris*, Fig. 4 and 5) is the most aquatic of the otters and the only one that can live permanently in the ocean. It coats its fur with the secretions of oily skin glands, making it waterproof. The fur retains a large number of air bubbles that provide thermal insulation and allow the young of the species to float. Its nostrils and ears are hermetically sealed while diving. Its hind limbs are longer, mostly flattened, and webbed: these are what the sea otter mostly uses for propulsion. The sea otter uses its tail as a rudder.

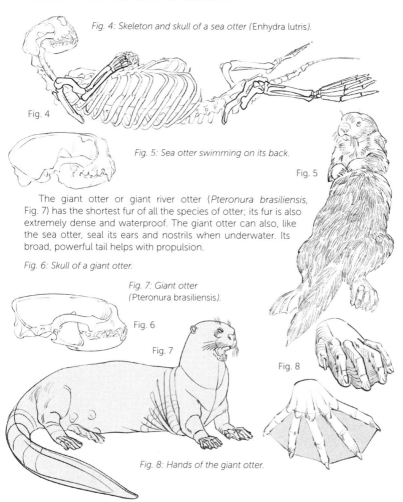

*Fig. 4: Skeleton and skull of a sea otter (*Enhydra lutris*).*

Fig. 4

Fig. 5: Sea otter swimming on its back.

Fig. 5

The giant otter or giant river otter (*Pteronura brasiliensis*, Fig. 7) has the shortest fur of all the species of otter; its fur is also extremely dense and waterproof. The giant otter can also, like the sea otter, seal its ears and nostrils when underwater. Its broad, powerful tail helps with propulsion.

Fig. 6: Skull of a giant otter.

*Fig. 7: Giant otter (*Pteronura brasiliensis*).*

Fig. 6

Fig. 7

Fig. 8

Fig. 8: Hands of the giant otter.

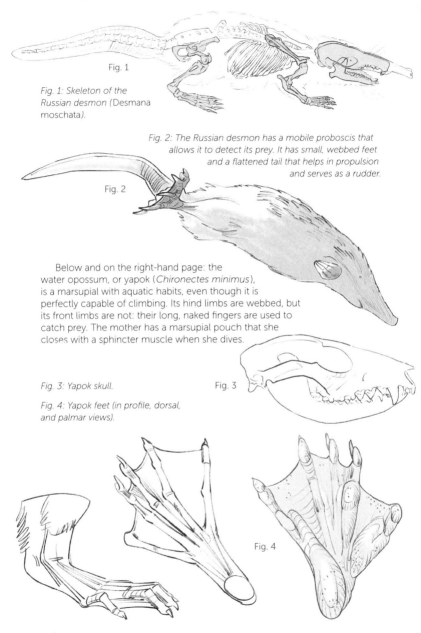

Fig. 1

Fig. 1: Skeleton of the Russian desmon (Desmana moschata).

Fig. 2: The Russian desmon has a mobile proboscis that allows it to detect its prey. It has small, webbed feet and a flattened tail that helps in propulsion and serves as a rudder.

Fig. 2

Below and on the right-hand page: the water opossum, or yapok (*Chironectes minimus*), is a marsupial with aquatic habits, even though it is perfectly capable of climbing. Its hind limbs are webbed, but its front limbs are not: their long, naked fingers are used to catch prey. The mother has a marsupial pouch that she closes with a sphincter muscle when she dives.

Fig. 3: Yapok skull.

Fig. 3

Fig. 4: Yapok feet (in profile, dorsal, and palmar views).

Fig. 4

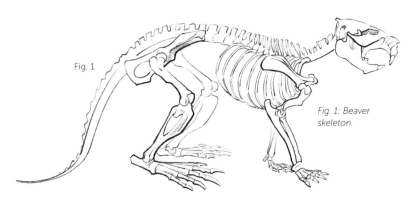

Fig. 1

Fig. 1: Beaver skeleton.

The Eurasian beaver or European beaver (*Castor fiber*, Fig. 1 to 5) has hands with five unwebbed, clawed fingers, suitable for burrowing. Gripping is facilitated by pads on the palm and a thumb that can naturally be oriented toward the inside of the hand.

Its foot has five completely webbed feet; the double nail of the second toe is used as a "comb" when the beaver grooms its fur.

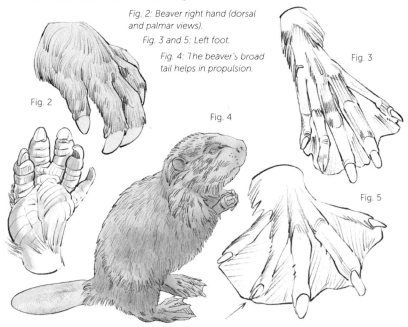

Fig. 2: Beaver right hand (dorsal and palmar views).

Fig. 3 and 5: Left foot.

Fig. 4: The beaver's broad tail helps in propulsion.

Fig. 2

Fig. 3

Fig. 4

Fig. 5

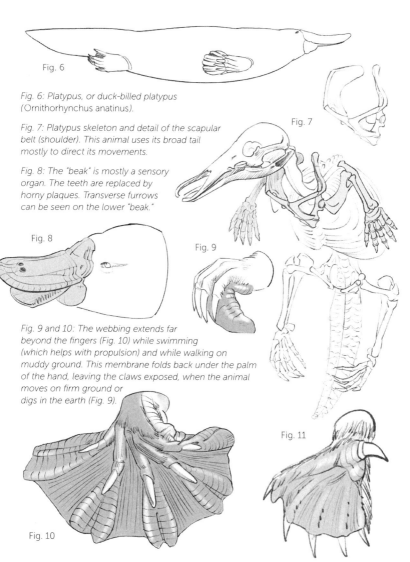

Fig. 6

Fig. 6: Platypus, or duck-billed platypus (Ornithorhynchus anatinus).

Fig. 7: Platypus skeleton and detail of the scapular belt (shoulder). This animal uses its broad tail mostly to direct its movements.

Fig. 7

Fig. 8: The "beak" is mostly a sensory organ. The teeth are replaced by horny plaques. Transverse furrows can be seen on the lower "beak."

Fig. 8

Fig. 9

Fig. 9 and 10: The webbing extends far beyond the fingers (Fig. 10) while swimming (which helps with propulsion) and while walking on muddy ground. This membrane folds back under the palm of the hand, leaving the claws exposed, when the animal moves on firm ground or digs in the earth (Fig. 9).

Fig. 11

Fig. 10

Fig. 11: The platypus is one of the few poisonous mammals, along with its cousins the echidnas and some shrews. Adult males have a pointed spur placed just above the heel.

The pinnipeds are carnivores adapted to marine life. They can be divided into two main groups: sea lions and seals. Sea lions, which have small ear flaps, can tuck their hind legs under their body and lean on them when they move along the ground. Seals have no ear flaps and keep their hind legs in line with their body, towing themselves along the ice by the claws of their front limbs.

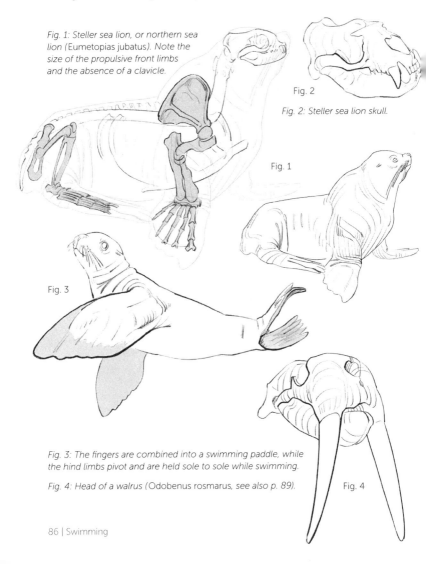

*Fig. 1: Steller sea lion, or northern sea lion (*Eumetopias jubatus*). Note the size of the propulsive front limbs and the absence of a clavicle.*

Fig. 2

Fig. 2: Steller sea lion skull.

Fig. 1

Fig. 3

Fig. 3: The fingers are combined into a swimming paddle, while the hind limbs pivot and are held sole to sole while swimming.

*Fig. 4: Head of a walrus (*Odobenus rosmarus*, see also p. 89).*

Fig. 4

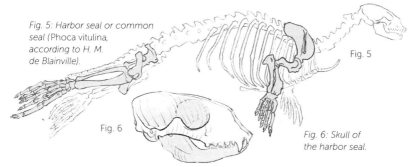

Fig. 5: Harbor seal or common seal (Phoca vitulina, according to H. M. de Blainville).

Fig. 5

Fig. 6

Fig. 6: Skull of the harbor seal.

The femur is extremely reduced, but not the tibia and fibula, which receive the musculature of the propulsive feet.

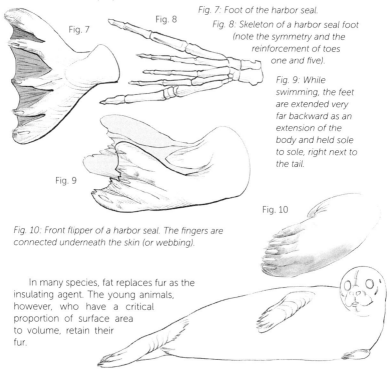

Fig. 7: Foot of the harbor seal.

Fig. 7

Fig. 8

Fig. 8: Skeleton of a harbor seal foot (note the symmetry and the reinforcement of toes one and five).

Fig. 9: While swimming, the feet are extended very far backward as an extension of the body and held sole to sole, right next to the tail.

Fig. 9

Fig. 10

Fig. 10: Front flipper of a harbor seal. The fingers are connected underneath the skin (or webbing).

In many species, fat replaces fur as the insulating agent. The young animals, however, who have a critical proportion of surface area to volume, retain their fur.

As a general rule, having a large body mass is an advantage for mammals, who are at risk of losing their body heat when in the water.

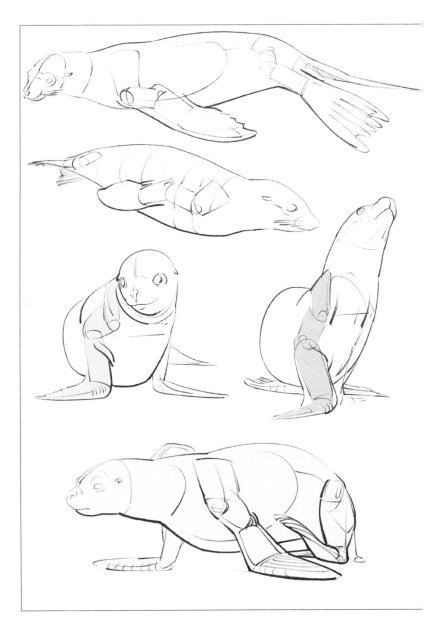

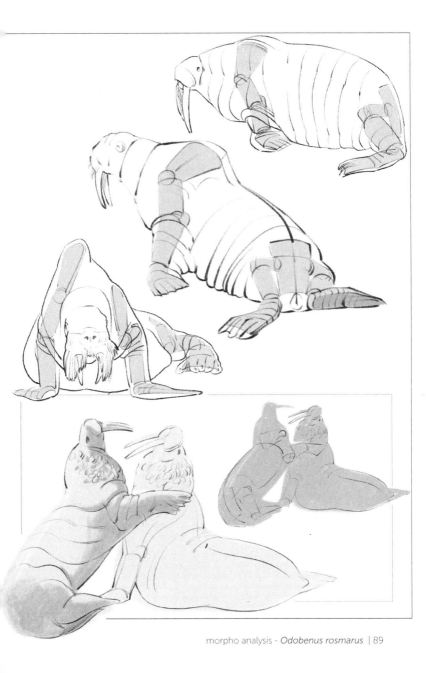

The sirenians, presented on this spread, are covered with a thick layer of insulating fat. They have no visible hind limbs (only vestiges buried in their flesh), but they do have a horizontal "tail fin" that allows them to propel themselves forward using vertical movements. They stabilize themselves and change direction using their forelimbs.

Fig. 1: Skeleton of a West Indian manatee (Trichechus manatus).

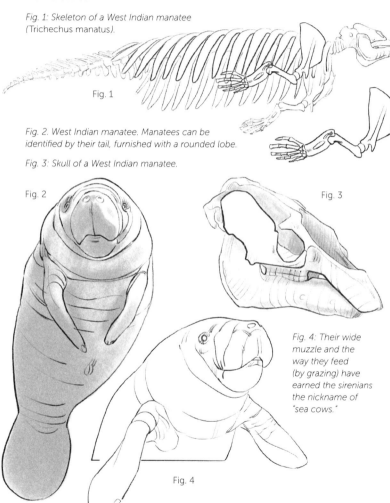

Fig. 1

Fig. 2. West Indian manatee. Manatees can be identified by their tail, furnished with a rounded lobe.

Fig. 3: Skull of a West Indian manatee.

Fig. 2

Fig. 3

Fig. 4: Their wide muzzle and the way they feed (by grazing) have earned the sirenians the nickname of "sea cows."

Fig. 4

Unlike the species we have seen so far, the sirenians and the cetaceans (seen on the following pages) are exclusively aquatic. Childbirth and breastfeeding take place in the water. Their morphological adaptation is completed by a large number of physiological adaptations. They are covered in a thick layer of fat (lard) which plays an insulating role, constitutes a reserve of energy, and helps with flotation.

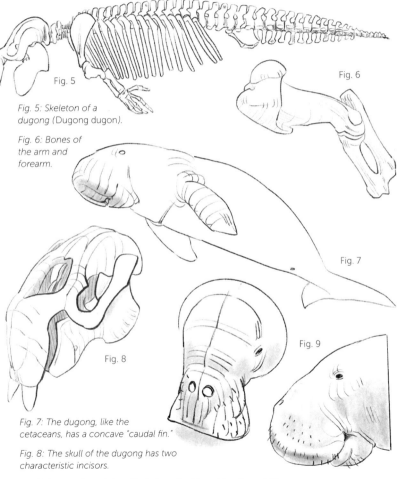

Fig. 5: Skeleton of a dugong (Dugong dugon).

Fig. 6: Bones of the arm and forearm.

Fig. 7: The dugong, like the cetaceans, has a concave "caudal fin."

Fig. 8: The skull of the dugong has two characteristic incisors.

Fig. 9: Its muzzle ends in a kind of small, widened trunk, useful for grazing on sea grasses and their roots.

The cetaceans, powerful animals with hydrodynamic shapes, show us how much the environment shapes living beings. Their heads are sunk into their shoulders (the neck is almost nonexistent, with the cervical vertebrae compressed and fused, Fig. 2 and Introduction p. 9), their forelimbs are shaped like swimming paddles, and they have no hind limbs (at the most, they have vestigial traces of a pelvis), but they do have a horizontal "tail fin" (which helps them rise to the surface to get oxygen) and stabilizing fins: these multiple adaptations make them look like fish. Their nostrils or vents tend to be higher up on their head than is the case for other aquatic mammals.

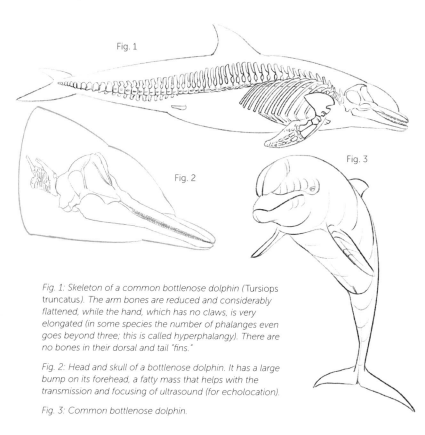

Fig. 1

Fig. 2

Fig. 3

*Fig. 1: Skeleton of a common bottlenose dolphin (*Tursiops truncatus*). The arm bones are reduced and considerably flattened, while the hand, which has no claws, is very elongated (in some species the number of phalanges even goes beyond three; this is called hyperphalangy). There are no bones in their dorsal and tail "fins."*

Fig. 2: Head and skull of a bottlenose dolphin. It has a large bump on its forehead, a fatty mass that helps with the transmission and focusing of ultrasound (for echolocation).

Fig. 3: Common bottlenose dolphin.

We distinguish between odontocetes (toothed whales) and mysticetes (baleen whales). The teeth of toothed whales are all similar to each other, with one exception: the narwhal only has one, its tusk (an incisor!).

Fig. 4: Orca, or killer whale (Orcinus orca).

Fig. 5: Narwhal, narwhale, or "unicorn of the sea" (Monodon monoceros).

Fig. 6

Fig. 7

Fig. 6 and 7: Sperm whale or cachalot (Physeter macrocephalus). The enormous head of this animal contains an organ (the spermaceti, or sperm oil, organ) that seems to play a role in controlling its buoyancy and in its echolocation.

Fig. 8

Fig. 8: Teeth line the lower jaw. On the upper jaw, they are rudimentary and rarely grow.

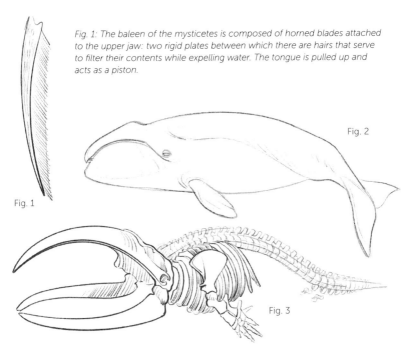

Fig. 1: The baleen of the mysticetes is composed of horned blades attached to the upper jaw: two rigid plates between which there are hairs that serve to filter their contents while expelling water. The tongue is pulled up and acts as a piston.

Fig. 1

Fig. 2

Fig. 3

Fig. 2 and 3: Bowhead whale or Greenland right whale (Balaena mysticetus).

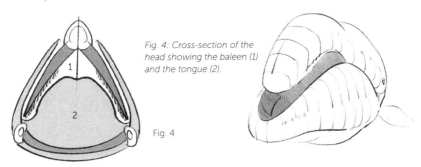

Fig. 4: Cross-section of the head showing the baleen (1) and the tongue (2).

Fig. 4

The bowhead whale is a "skimmer," swimming along slowly with its mouth open in order to harvest all of the small prey (like zooplankton) that are in its path. The underside of its throat and belly are smooth. Its tongue is firm and voluminous. Because its mandible is positioned so far down, its lips are very thick and very tall.

*Fig. 5: Drawings of the skeleton of the blue whale (*Balaenoptera musculus*) showing the rotation and spreading of two half-mandibles when the mouth is opened.*

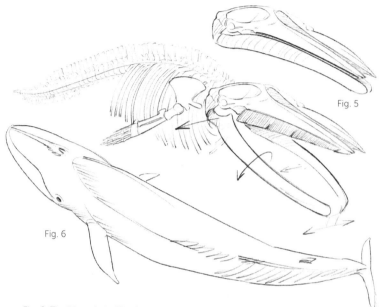

Fig. 5

Fig. 6

Fig. 6: The blue whale. The females, which are larger than the males, are the largest animals that have ever lived on our planet.

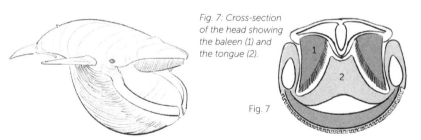

Fig. 7: Cross-section of the head showing the baleen (1) and the tongue (2).

Fig. 7

The blue whale is a "gobbler," with short baleen. The underside of its throat and part of its belly are pleated. Once the mouth is closed, the contraction of the powerful muscles situated underneath the pleats and of the tongue muscles drives the water out through the baleen, which retains krill, small fish, crustaceans, and squid.

I would like to thank Charlène Letenneur for her scientific editing. As a scientific illustrator, she works with researchers at a laboratory in the National Museum of Natural History as well as working independently for naturalist publications and exhibits. She submitted the manuscript of this book to several specialists and was thereby able to clarify the use of certain concepts. This simplified presentation, however, still contains some of the assumptions of the morpho series!

This book is the first of a new series dedicated to animal forms. I would like to take this opportunity to thank everyone who has been involved in this collection since the beginning: Viviane Alloing, Gwenaëlle Le Cunff, Carole Rousseau, Éric Sulpic, Eva Tejedor, and May Yang.

I particularly wish to thank my editor, Nathalie Tournillon, who provided the initial push that began this collection and who continues to influence its form and content for the better.

resources

The drawings collected in this book were made based on many different photographic and video sources available on the internet. Some of them were based on the comparative anatomy collection of the National Museum of Natural History, in Paris. Most of them were traced from photographs, to reduce the margin of interpretation (and to save time!). I have made an effort to draw these skeletons in natural postures, while respecting the positioning of each of the bones, as far as I was able. X-ray data remains rare, and a margin of error inevitably persists. Nevertheless, I hope that these drawings will inspire you and will encourage you to pursue this research further on your own.

The list of useful books is very long. Here are a few of them.

Collectif, *Histoire naturelle: plus de 5,000 entrées en couleurs*, Paris, Flammarion, 2016.

Jean-Baptiste de Panafieu and Patrick Gries, *Évolution*, Paris, Xavier Barral and National Muséum of Natural History, 2011.

Charles Darwin, *L'Origine des espèces* [The Origin of Species], Paris, Flammarion, 2008.

Charles Devillers and Pierre Clairambault, *Précis de zoologie, vol. I: Anatomie comparée*, ed. Pierre-Paul Grassé, Paris, Dunod, 1976.

Wilhelm Ellenberger, Hermann Dittrich, and H. Baum, *An Atlas of Animal Anatomy for Artists*, Dover Publications Inc., 1956.

Ernő Goldfinger, *Animal Anatomy for Artists*, Oxford, Oxford University Press, 2004.

Pierre-Paul Grassé, ed., *Traité de zoologie*, vols. XVI and XVII, Paris, Masson et Cie, 1950–1970.

Leonard Harrison Matthews, *La grande encyclopédie de la nature*, vols. XV and XVI: *La vie des mammifères*, Paris, Bordas, 1972.

Ken Hultgren, *The Art of Animal Drawing*, Dover Publications Inc., 1993.

Guillaume Lecointre and Hervé Le Guyader, *La classification phylogénétique du vivant*, vol. II, Paris, Belin, 2017.

Jacques Monod, *Le Hasard et la Nécessité*, Paris, Seuil, 1973.

And all the works of the American paleontologist Stephen Jay Gould!